BARRON'S ART HANDBOOKS

BARRON'S ART HANDBOOKS

COLORED PENCILS

BARRON'S

CONTENTS

CONTENTS

POSSIBILITIES OF THE COLORED DRAWING

The characteristics of colored pencils allow us to bring together in a single work some of the most basic color drawing techniques and effects. With a sound knowledge of the materials and a suitable technique, the expressive possibilities of this medium are ideal for practicing, exploring, and discovering the nature of color, their combinations, harmonizations, and variations.

The colored drawing

Drawings do not always have to be monochromatic, since this medium does not exclude the incorporation of color (despite the fact that many believe otherwise). The colored drawing possesses a very brilliant chromatism and unmistakable pictorial reminiscences. With something as simple as colored pencils, illustrators and advertising artists are able to obtain results of outstanding quality. It should be pointed out that the colored pencil technique differs little from that used to draw with ordinary graphite lead pencils. The main difference is that instead of relying on the values of a single tone, such as in a monochromatic drawing, the artist uses color, but the technique is basically the same: shading, taking full advantage of the color of the paper, and executing the work through lines or tonal patches.

Getting started in drawing

The colored pencil medium is ideal for learning how to paint and blend colors. It allows the artist to study and experience through practice how it is possible to compose almost all the colors of the spectrum using only black and

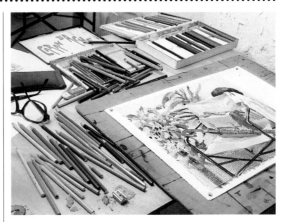

In addition to offering a wealth of chromatic gradations, colored pencils are essentially a drawing medium.

three colors. The colored pencil drawing is the first step on the road to painting, because it frees the artist from the technicalities of the medium itself, thus allowing him or her to concentrate on drawing in pencil and to resolve the basics of mixing and composing.

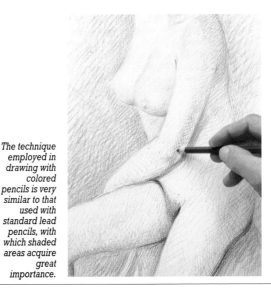

The technique employed in drawing with colored pencils is very similar to that used with standard lead pencils, with which shaded areas acquire great importance.

MORE INFORMATION

• Composition and characteristics, **p. 26**

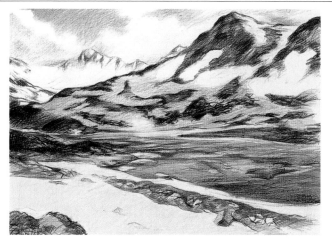

Color mixtures are based on superimposed strokes, which from a distance appear to merge together.

A drawing medium

When working with colored pencils, the main difference between drawing and painting becomes vague. Indeed, the limits are so imprecise that many works that could be classified as drawings may take on an entirely pictorial conception and vice versa. The problem, then, resides in the question of concept. Colored pencils, due to their direct and dry application, are obviously drawing instruments, and the tonal values they yield are much closer to drawing than painting.

Children's drawing tools

The fact that boxes of colored pencils are associated with children's drawings, together with the general lack of knowledge concerning the material and its possibilities, for a long time relegated the colored pencil drawing to a secondary place, erroneously regarding it as a technique lacking in prestige and importance. This could not be further from the truth. The Impressionists like Ramon Casas, the post-Impressionists like Toulouse-Lautrec and the avant-garde like Henri Matisse and Picasso had no qualms about working with this medium, which today is largely regarded as school material.

Colored pencils have traditionally been associated with children.

With colored pencils it is possible to execute drawings in all manner of styles.

THE SYMBOLIST MASTERS

Symbolism was the first artistic movement to adopt colored pencils as the most suitable medium for expressing their aesthetic ideal. The delicate chromatism and evanescent profiles produced by colored pencils were highly suited for recreating an idealistic and mysterious iconography, which led to an obsession for recreating light and atmosphere in their works.

A new medium for the Symbolists

The Symbolists used this new drawing medium to create evanescent images, with undefined and phantasmagoric outlines, of figures from an unreal and ephemeral world. The softness of the stroke and the delicate nature of the coloring contributed to enhancing this subtle and introspective style advocated by Symbolism. The Symbolists did not refrain from instilling a message of a philosophical, moral, or spiritual nature in their works, and this led them to put into practice complex chromatic constructions, building on certain aspects of the neo-Impressionist aesthetic, allowing the presence of the stroke through sinuous lines that lead the eye over the surface of the drawing. The purpose of the Symbolist technique was to permeate the drawing with suggestion, indecision, and opacity, very suitable factors for highlighting fantasies of the imagination.

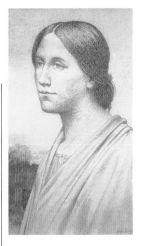

Alexandre Séon, Pensive Woman, 1900. Private collection (Paris, France)

The lyrical perfection of Schwabe

Carlos Schwabe was one of the first Symbolist painters to take the colored pencil drawing to new heights of perfection. In his works, the artist used a combined drawing technique (executing the work based on faint shadows and finalizing it with sparing touches of white gouache) with an unusual virtuosity and a treatment of extraordinarily toned-down colors. Through his drawing, filled with archaism and freshness, together with his idealism, he became recognized as one of the finest illustrators of his time.

The photographic naturalism of Klimt

His first figures, influenced by symbolism, fall within a broad allegorical context.

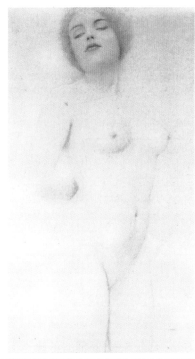

Fernand Khnopff, Study of a Nude, 1910. Private collection (Brussels, Belgium)

Possibilities of the Colored Drawing
The Symbolist Masters
A Brief Survey of 20th-century Artists

9

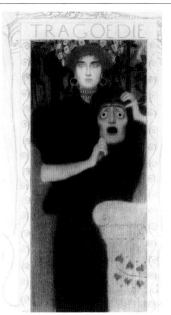

Gustav Klimt, Drawing for the allegory Tragedy, 1897. Historisches Museum (Vienna, Austria).

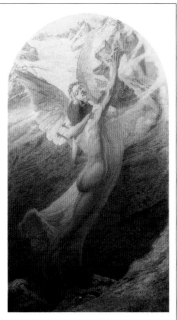

Carlos Schwabe, The Marriage, the Poet, and the Muse or The Ideal, 1902. Private collection (Paris, France)

The visible pencil lines lend his works a certain Impressionist character. Notwithstanding, the precise detail achieved with colored pencils allowed him to render faithful representations of the figures of antiquity with a decidedly sculptural appearance. In this way, the artist attempted to preserve the authenticity of ancient tradition as seen through the eyes of his time.

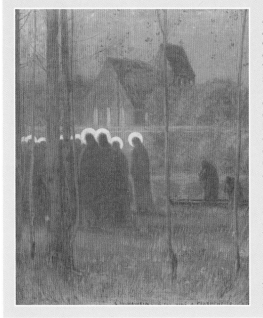

An attenuated chromatism

Although they clearly advocated color drawing, the symbolists chose an attenuated chromatism that allowed their characteristic simplification of forms and chromatic contrast. Such choice was due to what they intended to convey: mysticism and spirituality, which would have been difficult to transmit if they had chosen another variety of color drawing, such as strident tones and violent chromatic contrasts, so typical of Fauvism. In Symbolist drawings, the tonal limitations and different gradations of grays and browns envelop the works with a slight air of melancholy.

Louis Welden Hawkins, Procession of the Souls, 1893. Private collection (Paris, France)

A BRIEF SURVEY OF 20TH-CENTURY ARTISTS

As has already been demonstrated through the work of numerous artists, colored pencils provide us with a medium to tackle all manner of styles and factures. From the most modern drawings for their concept and execution to the works with a meticulous academic finish, the delicate nature of this type of work in pencil allows a unique versatility and quality.

Impressionism

Colored pencils were first industrially manufactured toward the end of the 19th century. Their introduction into artistic fields coincides with the revival of color spread by Impressionism. This led many artists to use this medium for sketching landscape studies with results very similar to those achieved with paint. Given the medium's lightness and cleanliness, its use became widespread among artists who painted outside the studio, and in this way it provided a graphic account of excursions and travels. Impressionist drawings reveal an interest in the conception of light and the vibrancy of color. This style was achieved with very disparate, energetic, and long strokes. Among the many artists to draw with colored pencils, Pissarro and Toulouse-Lautrec are two of the most outstanding.

Dario de Regoyas, Three Women in a Market in Galicia, *Museu Nacional d'Art de Catalunya (Barcelona, Spain).*

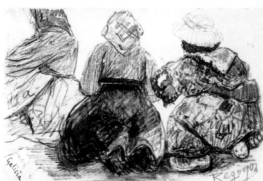

Picasso

Throughout his artistic career, Picasso frequently resorted to colored pencils in order to execute many of his drawings. This medium, nonetheless, rarely appears alone on the support, but rather is invariably combined with wax, wash, and India ink. Many of Picasso's works share and dis-

Pablo Ruiz Picasso, Three Women, *1966–1967. Ludwig Collection.*

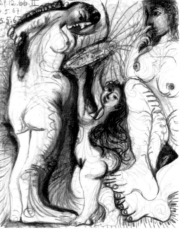

play certain childlike drawing features, which are reflected in both the way color is applied and the naive and deformed appearance of the figures. Picasso's work often amazes us with works that have been drawn very quickly and spontaneously, with a well defined contour that the painter executes with seemingly disorderly and intense strokes.

CoBrA: a new primitivism

The artistic group CoBrA was founded in 1948 primarily by artists from Copenhagen, Brussels, and Amsterdam. They were influenced by the formal characteristics of primitive art, ethnography, and children's drawing, which they regarded as the most primitive manifestation of the human being and a source of purity uncontaminated by civilization, on which they

The Symbolist Masters
A Brief Survey of 20th-century Artists
Pencils and the Illustration

11

Karel Appel, pages 36 and 37 from the notebook Psychopathological Art, 1947–1950.

based their works. Thus, artists from CoBrA such as Dotrementt, Noiret, Constant, or Appel reproduced in their works the awkward and insecure lines of infantile drawing and adopted wax crayons and colored pencils as their main medium of expression.

A recent popularity

Ever since David Hockney set the precedent during the 1960s, with his series of drawings executed with colored pencils, this medium has grown in popularity among painterly artists. To such an extent that manufacturers of colored pencils, aware of this popularity, have placed on the market colored pencils that are soluble in water and soluble in turpentine, thereby increasing the technical possibilities of this medium still further.

David Hockney, Still Life with Jacket, Hat, Briefcase, Notebook, and Chair.

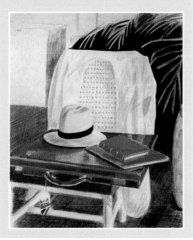

David Hockney

The contemporary artist David Hockney is an outstanding draftsman. His style, immersed in the realism derived from the Pop Art of the sixties, presents works of great formal simplicity. At the beginning of the 1970s, he drew a number of pictures with colored pencils based on a stylized realism from photographic models. Hockney's drawings reveal the spontaneity with which he approaches this medium, with a soft clarity of color and great skill at juxtaposing and superimposing tones and lines.

David Hockney Portrait, Private collection.

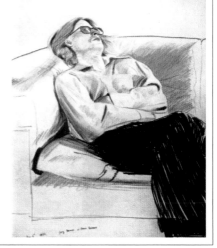

PENCILS AND THE ILLUSTRATION

Illustrators use colored pencils as their work medium. In fact, this medium is one of the most utilized techniques, combined with other auxiliary media such as watercolor, gouache, acrylic, and felt-tipped pens. There are various advantages to colored pencils, such as, among others, the permanency and inalterability of the colors and the possibility of working the illustration down to the highest degree of detail.

The importance of the drawing

The work of the graphic illustrator is based on the drawing, with the result that colored pencils play a key role among the professional's materials. Regardless of whether the illustration is realistic or not, a mastery of drawing is a basic requisite of all illustrators. Normally, an illustrator must be versatile enough to represent all types of subject matter, for which reason it is indispensable that he or she have the flexibility required of the profession. The illustrator's education, in terms of drawing, is no different from that of the painter: he or she must have a thorough grounding in linear

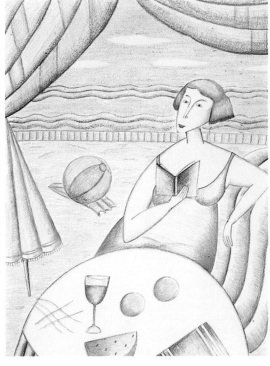

Colored pencils can be used to obtain illustrations as attractive as this by M. Angels Comella.

and shading techniques and be able to render figures and objects in movement or static, in addition to possessing a knowledge of the basics of perspective and composition.

Technical resources

The main resource of the illustrator who draws with colored pencils is the texture of the paper, which becomes most evident as the roughness of the texture increases. Some professionals, before beginning to paint, scratch or score the surface with a stylus or

Abstract illustration by Joaquim Chavarria.

A Brief Survey of 20th-century Artists
Pencils and the Illustration
Optical Color Mixtures

13

MORE INFORMATION

- Possibility of drawing in color, **p. 6**
- Practicing with watercolor pencils, **p. 54**
- Love of botany, **p. 56**
- A decorative illustration, **p. 76**

Colored pencils yield excellent results for both decorative and realist illustrations. Work by Maria Pilar Amaya.

trations in children's books that have been drawn using a combination of colored pencils and watercolors. These illustrations call for pleasant colors and a clear and intelligible interpretation. Illustrators working for children's publications tend to specialize in this type of work, since there are certain basic rules that they must master regardless of their own style.

similar point in order to create furrows and textures that are then brought out with shadings of colored pencil.

Nonetheless, the most widespread use of colored pencils is their combination with wash; the pencils constitute a useful complement for drawing, shading, and lending volume to forms previously painted with flat colors. This combination is almost traditional among illustrators, who eventually enhance it with posterior retouching using gouache or pastel.

Decorative and children's illustrations

Decorative illustrations and those destined for children's stories are often done in colored pencil. Decorative illustrations are those that accompany texts in order to adorn the page. They are usually marginal illustrations that enhance the publication's graphic design. They are closely linked to the overall design of the book or magazine and almost always constitute a technical, didactic, or documentary complement. We can also find an abundance of illus-

Small formats

Colored pencils cannot be used to draw very large drawings because the intensity of the tone and the color's covering capacity are far more limited than other media. Colored pencils are best used for drawing detail rather than for the large painterly effects produced by charcoal, pastel, or ink. But this limitation is also their most interesting aspect, as they demand a careful, delicate and sensitive treatment.

Colored pencils are used for drawing small formats.

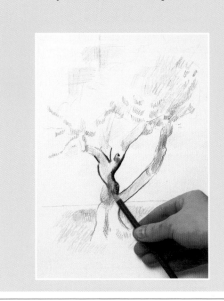

OPTICAL COLOR MIXTURES

With colored pencils, the mixtures are obtained by superimposing layers of color. In order to do this correctly, it is essential to master the colored pencil technique. One color is applied over another by means of shading or hatching. The result of this procedure is an optical color mixture that occurs through the superimposing of colors or glazes.

Obtaining a color

The most noteworthy characteristic of drawing with colored pencils is the subtle optical mixtures they allow.

The interest of the pencil drawing largely resides in the wealth of intensities of each tone, more than in the brightness and variety of colors, and the way they combine through an optical phenomenon on the paper achieved by shading.

This type of superimposing requires advance planning and must be carried out in a specific order: light colors must be superimposed over dark ones; light colors cover less and allow the underlying layer of color to remain visible, a necessary condition for obtaining the desired color.

All colors with only three colors

There are three basic colors that when mixed together allow (in theory) all the other colors to be obtained. These three colors, red, blue, and yellow, are known as the primary colors.

By superimposing the three primary colors in pairs, we get the secondary colors: orange, violet, and green. On the other hand, by superimposing the three colors together, we get something akin to black.

It is recommended to practice the techniques of superim-

By superimposing the three primary colors: yellow, red and blue, we obtain new colors: orange, violet, green, and black.

posing and gradating using these three colors. When they are combined, you will have to retouch the intermediate zones in order to cover any white areas and avoid abrupt alterations in color. Studying and

practicing the mixing of these three colors is fundamental. Professional artists, nonetheless, always work with broad ranges of color (to avoid having to make too many color mixtures), among which both the primary and secondary colors are included.

Contrasts

In practice, the contrast is interesting so long as it is not used in excess. Applied to a painting, it is good to have small touches of contrast, provided it falls within the overall harmony of the predominant tone.

The juxtaposing of complementary colors, that is, placing one color beside another, produces the maximum chromatic contrasts.

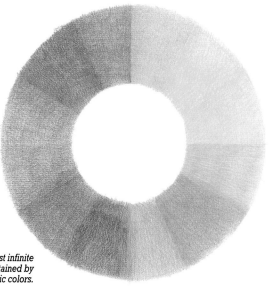

This color wheel shows the almost infinite number of tones that can be obtained by combining the three basic colors.

These gradations allow you to gain practice with colored pencils to obtain all the colors of the spectrum using only the three primary colors.

the same color when one of them is darker than the other. On the other hand, in any other way, we still encounter the simultaneous contrast, which is the same as saying that the intensity of the color depends on the surrounding color: all colors appear darker when situated against a lighter background, and inversely, they appear brighter when surrounded by a dark background.

This is the most important thing to keep in mind when painting and harmonizing the color. In addition to the contrasting of complementary colors, mention must also be made to the tonal contrast produced between two patches of

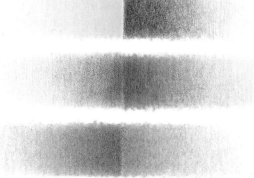

Complementary colors are those that create the most contrast.

Pointillism

Pointillism is the technique of applying tiny strokes of pure color to the paper, such that when observed from a distance the different applications of strokes appear to blend into a unified whole. By applying this technique with colored pencil, it is possible to achieve a remarkable brilliance and luminosity as well as an interesting atmospheric effect.

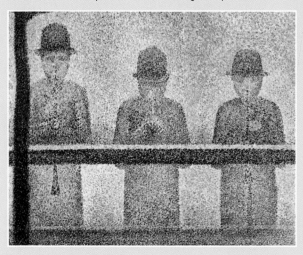

Georges Seurat, Side Show (detail), 1887–1888. Metropolitan Museum of Art (New York, USA).

COLOR MIXTURES (1)

When drawing with colored pencils, we obtain the color mixtures by superimposing layers of color. In order to carry this procedure out correctly, a mastery of the colored pencil technique is required. By some simple shading, one color is applied over another on the paper in the manner of glazes. This section provides some examples of color mixtures in order to help you to become familiarized with this technique.

Mixing chart

You will only need the three primary colors, and nothing else, to carry out this exercise. This is a fundamental lesson for learning about the possibilities of pencils and the astonishing results that can be achieved through blending. The work must be carried out without any visible lines; in this way the mixture will be executed through blending. Using this method, the slightly waxy consistency of the lead aids the physical blends and lends it a more homogeneous result.

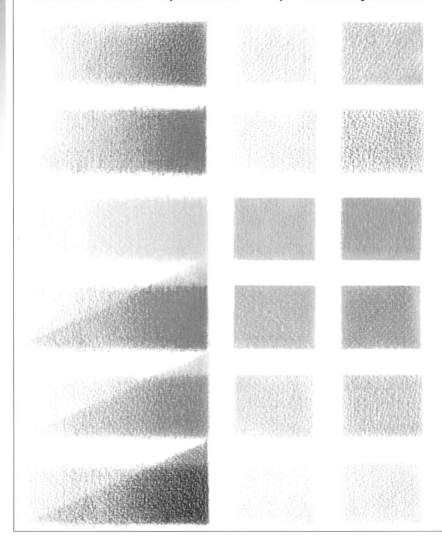

Color mixtures

Drawing and observation: sketches

First we will practice three gradations with the primary colors, applying only a little pressure at first and then, as we advance to the right, gently increasing the pressure. Next, in the succeeding boxes we develop new gradations in green, violet, and orange, combining blue and yellow in unequal parts to get green, red and blue to get violet, and yellow and red to get orange. We do likewise in the boxes in the bottom half of the page, only this time combining the three colors, that is to say, applying three layers of color instead of two, with the aim of obtaining the neutral colors.

Neutral colors

When we mix the three primary colors in unequal proportions or two complementary colors also in different proportions, we obtain lighter or more defined colors, depending on the proportion applied. By breaking down the basic colors, we obtain a variety of browns, greens, and grays. To work with a range of neutral colors requires a sound knowledge of how to mix the complementary colors together correctly.

Only through practice will the artist achieve greater profundity and a wealth of color in drawing.

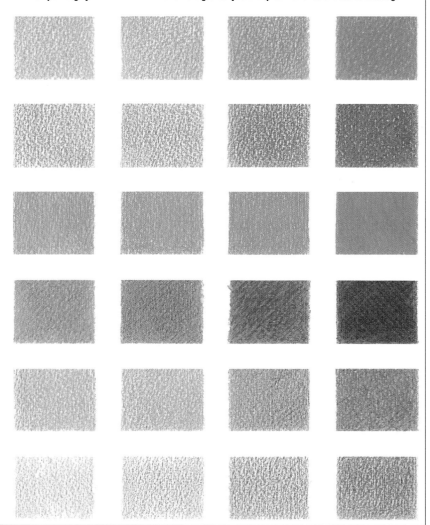

DRAWING AND OBSERVATION: SKETCHES

The most interesting aspects of an artist's production are often found less in the finished works than in their sketchbooks. The sketches contain an authentic record of the artist, as they are the most immediate impressions of the world surrounding him or her.

The importance of drawing from nature

Colored pencils yield their best possibilities in the execution of sketches when they are used as a drawing medium rather than a painting medium. If the maximum expression of a drawing is the line, the plentitude of the work with colored pencils resides in the interplay of colored lines. It is not easy to come across subjects that easily adjust to this requisite, as most objects in reality are three-dimensional, in other words, they are volumes, and not collections of lines. As such, the artist must learn how to translate the volumetric bodies of reality into strokes and lines.

Squiggles

The squiggle is perhaps the most frequent stroke in the sketch. Squiggles or random strokes consist of agitated lines, executed in the manner of outlines and gestures. These are strokes that the artist draws in an almost intuitive manner, a type of gestural warm-up. Artists often resort to this technique when they only have a few minutes in which to draw or capture the subject, which results in a greater expressive effect.

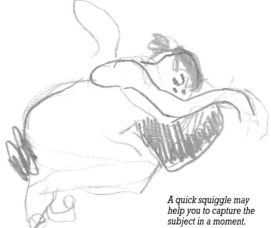

A quick squiggle may help you to capture the subject in a moment.

Sketchbooks

Despite the omnipresence of the photographic camera in our travels, the sketchpad is an artist's most valued piece of equipment. It is recommended to always carry a sketchbook or sketchpad and a pencil box with a selection of colored pencils to be able to draw whenever and wherever the occasion arises.

Having a sketchpad at hand allows you to draw at any time. The more you practice, the greater the dexterity your drawings will acquire.

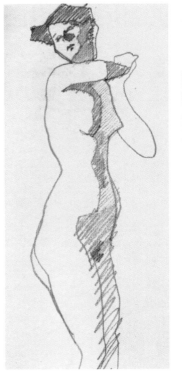

In this sketch of a nude, the painter Amedeo Modigliani has made use of the silhouette technique.

When drawing a tonal sketch it is preferable to color faintly and avoid lines.

Silhouettes

Silhouetting consists of describing the model by means of contours that outline objects. This technique can be likened to the contours of a topographical map, in which each line represents the relief of the terrain. In order to render drawings of this nature, based on lines, with a volumetric appearance, it is essential to vary the qualities and thicknesses of the strokes and lines.

By varying the intensity of the line, it is possible to convey the sensation of space and volume, even when it is used only as a contour line. Practicing the synthesis technique sharpens your visual perception and allows you to discover aspects of the model that would otherwise go unnoticed in more normal circumstances.

Tonal sketches

In the same way that you can draw with only lines, you can likewise make a sketch based entirely on patches or shaded areas. In this case, the artist first resolves the general tone, without stopping to concentrate on shapes or produce contrasts, followed by the intermediate tones and ending with the application of more intense strokes.

The value is defined based on a range of shadings over the model that are sufficiently complete and contrasted in order for the shapes to acquire definition, volume, and depth. Tonal sketches have a markedly atmospheric and pictorial appearance. Textured paper provides the best support for this type of sketch.

MORE INFORMATION

- The value of the line, **p. 34**
- The sketch, **p. 52**
- Love of botany, **p. 56**
- How to get started in drawing, **p. 62**

THE COLOR DRAWING AND THE LANDSCAPE

Colored pencils offer the possibility of coloring in a very detailed and precise manner, by accumulating short strokes, glazes, or gradations, alternating a diversity of colors and playing at all times with the intensity of the lines and the white of the paper. Thus the artist achieves very rich and attenuated chromatic effects, a sensation of the intervening atmosphere, and interesting textures that enhance landscape drawings.

The most popular subject

At present, the landscape is one of the most popular motifs among artists. The main reasons for this are, firstly, it allows a broad creative margin, and secondly, it does not require as much rigor in the proportions that are so essential to the figure, the still life, or the portrait. It is also one of the most pleasant subjects, as the likeness with the model need not be so exact. Furthermore, good results can be achieved using any type of drawing media. It was the Impressionists who enriched their vision of the landscape. They departed from conventional landscapes marked by traditional tendencies and developed new and fresher visions with a more uninhibited and loose technique.

The landscape is one of the most popular subjects among artists.

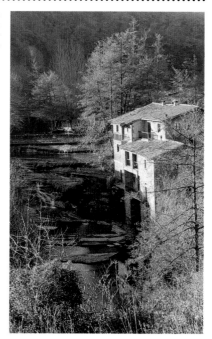

Choosing the subject

Any landscape will do, although it should meet a number of criteria in terms of the value of the shadings, the framing, and the composition. These characteristics must cover the possibility of interplays between contrasts, in such manner as to produce a dynamism by playing with the light and dark volumes.

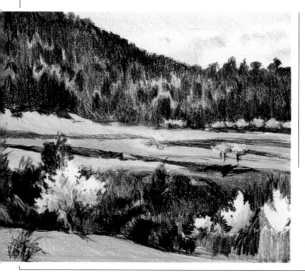

The landscape is an attractive subject due to the diversity of textures contained within it and the effect of depth.

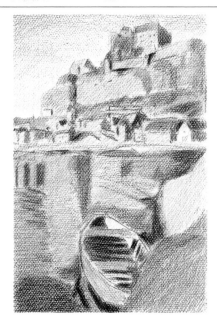

It is most important to study the composition of the landscape and decide which part you wish to represent.

The texture of the vegetation is achieved by superimposing series of tiny strokes.

The atmosphere

The simulation of the intervening atmosphere is one of the most common effects used by artists to lend a landscape a sensation of space and depth. In order to put this into practice, we must ensure that the foreground in a drawing is sharper and has more contrasts than the middle ground and background. As the grounds recede into the distance, they lose their color and become hazy.

When drawing a landscape, the capacity to recreate the shapes of trees and bushes depends on the subtle gradations of tone and color. The representation of the sky and the sea often require the use of tonal gradations.

The texture of vegetation

When drawing landscapes, it is indispensable to study the direction of the strokes, especially when working on the foreground, since the planes of the picture are totally conditioned by the direction of the lines that form them. This means that the water of a lake should be drawn with long and horizontal strokes, the sky should be combined with an enveloping stroke if there are clouds, the texture of a thicket should be drawn with simple squiggles, and a grassy field should be tackled with vertical hatching.

The tones of the pencils

Colored pencils can be applied with various techniques, and often come in handy when creating glazelike effects and superimposing colors over darker layers. Working with the utmost attention, the artist is able to render the intervening atmosphere of a landscape.

The soft areas of shading of Vicenç Ballestar enhance the sensation of depth and the intervening atmosphere.

COLOR MIXTURES (2)

The artist can obtain richer and more luminous tones by drawing and coloring at the same time, instead of working with a limited color range. Each color has one or various tones or values. These values depend on the quantity of pigment that is extended over the surface of the paper. To avoid working with a very broad range of colors, which can be very confusing, we have provided a number of rules that one should have in mind when mixing or blending colors.

Blending

The blending technique allows two or more colors to be merged together. This is a standard procedure in drawing.

The artist begins by creating a tonal gradation, that is, tracing a pencil up and down in a zigzag fashion, gradually reducing the pressure applied to the lead over the paper. During the process the colors merge together by way of the superposition of the colors. This

We can blend two colors in the form of a gradation.

MORE INFORMATION

- Color mixtures (1), **p. 16**
- Hatching, **p. 42**
- Applying glazes, **p. 46**
- Mixing with only three colors, **p. 48**

technique requires steadfast practice and an observant analysis of the result. In short, it consists of superimposing the gradation of the second color over the first, but inverting the pressure, that is, applying the maximum pressure over the faintest area of the underlying color and vice versa.

Color range

One of the frequently used methods for representing the

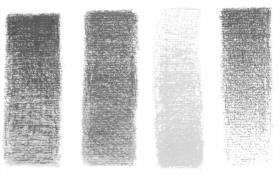

Tonal blendings with warm colors, ochres, and earth tones.

Tonal blendings with ranges of blues, greens, and violets.

Which color should go on top?

With colored pencils, it is not the same to first apply one color and then add another on top of it than to do it the other way around. The order in which the colors are applied has a direct influence on the result. The reason is that the waxy composition of colored pencil lead makes the first layer act as a reserve for the subsequent colors. Here is an example.

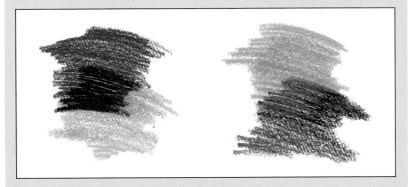

The result depends on the order in which the colors are superimposed. Here we have mixed orange and blue by, in the first case, applying the light color over a dark color, and in the second case, doing exactly the reverse. Note that the result in either case is not always predictable.

volumes of a body consists of drawing gradations based on a single range of colors. This is an extremely simple procedure.

First choose the color range. Identify the predominant color of the object. The rest of the colors will be chosen accordingly, since they will only be used to lighten or darken it. It is recommended to first test the blending of the range with a gradual transition from light to shadow. These gradations are obtained using various colors, which must be added in the correct order. First a patch of the first color is painted. Next, another patch is applied with the second color, which is allowed to overlap the first. Now we have a patch colored with the first color, another one with both colors blended, and a third one colored with the second color. Following an analytical procedure, we can gradually incorporate in order the next colors, the third, the fourth, the fifth, etc. Finally, all that remains is to carry out a few adjustments. It is almost always necessary to go over some of the colors in order to obtain a uniform gradation.

Blending through hatching

Mixtures obtained through hatching are differentiated from uniform shadings in that the lines made by the tip of the pencil are apparent. The superimposing with hatching of two different colors allows optical color mixtures to be obtained. This technique requires the artist to draw series of lines of different colors close together, or superimpose strokes at a right angle, in order to create the illusion of a third color. As was previously mentioned, a mixture comprising hatching is above all optical, which means that the retina mixes the colors together when viewed from the right distance.

This mixture is obtained by superimposing hatching of different colors.

HIGHLY DETAILED DRAWINGS

The careful selection and representation of the laboriously gradated areas of light and shadow, the softness of the shading as well as the smoothness of the modeling and of the color mixtures gives rise to a highly realistic rendering of objects. This delicate work produced by very well sharpened colored pencils makes it an ideal medium with which to execute drawings of a high resolution, with seemingly photographic finishes.

Photographic realism

In highly detailed drawings, the artist strives for a conventional presentation of the model, in other words, rather than interpreting reality, the artist attempts to reproduce what a photographic camera would capture. Many drawings based on a conventional type

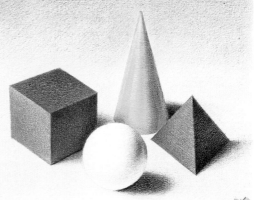

Highly detailed drawings are based on a correct assessment of the value and representation of volume. Drawing by Miquel Ferrón.

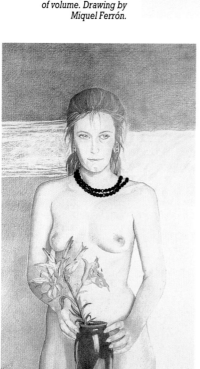
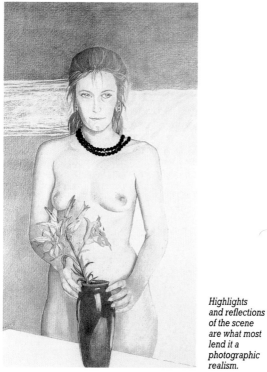

Highlights and reflections of the scene are what most lend it a photographic realism.

of representation astound the spectator for their photographic realism thanks to the use of a complete tonal range. It is even possible to achieve very realistic surface textures of metal objects, as well as of rough textures and even reflections on glass. To draw a highly detailed drawing demands ample experience and plenty of patience from the artist, as a work of this nature can take several days to complete.

A love for detail

In large part, the details are what most instill photographic realism in a drawing. However, they should not be dealt with separately, but instead should be related to the overall structure that provides them with a base. Frequently, the suggestion of a surface texture of the object represented, in addition to an entire range of intermediate

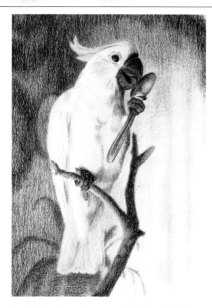

Esther Rodriguez achieves realism by mitigating the stroke, thereby obtaining a more atmospheric drawing.

With the pronounced highlights and the direction of the hair, Miquel Ferrón achieves an almost photographic effect.

tones, is enough to achieve a high-resolution work. A fact that implies that in order to work on this type of drawing, it is essential to have a wide range of colors.

MORE INFORMATION
- Love of botany, **p. 56**
- The delicateness of the portrait, **p. 74**

Finishing techniques

In this type of drawing, the modeling must be carried out very softly, without any abrupt changes in tone. The line and the stroke should disappear in order to make way for the tonal gradation. Each fragment of the work must be resolved with the utmost detail, describing with resolute strokes highlights, reflections, and surfaces. To achieve high-resolution details, it is necessary to work with the edge of a ruler in order to avoid overlapping into sections that are to be left in reserve. Curved areas may be protected with a fine sheet of aluminum or a mask made of cardboard. If you are a good and patient observer, you can create an image to its last detail.

The sharpened lead

It is important to draw with well-sharpened leads, in order for the details to take shape as you are coloring. Pencils with a rounded tip produce imprecise coloring, and they cannot be used to adjust the contours correctly. To keep the tip sharp when drawing, you should continually change the position of the lead, in order to ensure you draw with the sharpest edge and to keep the tip thick enough.

Drawing details requires the artist to draw with well-sharpened pencil tips.

COMPOSITION AND CHARACTERISTICS

You may either make use of many colors or work with just a few. Over the last few years, there has been a notable increase in the assortment of colors and a number of varieties of colored pencils have been introduced that enhance the possibilities of this medium. Not only have the range of colors been increased, but now they are available in different gradations and are more resistant to light.

Composition

Colored pencils are clean, practical, and easy to carry. They are manufactured along the same lines as ordinary graphite lead pencils. The lead is made of pigment, a filling, generally chalk, talc, or kaolin, and a binder, which is almost always cellulose rubber. Colored pencils are handled in the same way as standard lead pencils and they produce a less greasy result, which looks softer and more satiny. They can be used with the same degree of precision

Placing the pencils in order of their color ranges facilitates the artist's work.

Colored pencils are normally sold in cardboard, metal, or wooden boxes.

as graphite pencils, while at the same time applying color to the paper; they are soft enough to obtain subtle shadings and they can be sharpened in order to obtain more intense lines. Their stroke is somewhat faint. Unlike graphite pencils, colored pencils only have two different degrees of hardness.

Assortments

Colored pencils are sold both individually and in boxes. Most brands manufacture the college-type, in boxes of 12 to 36 colors, although here we are referring to a higher quality, which are generally sold in metal boxes and come in assortments from 12 to 72 pencils of different colors. It is

The leads of colored pencils are manufactured with pigment, talc, and a greasy binder.

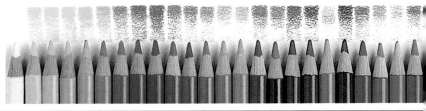

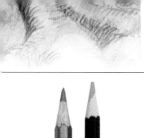

Professional artists work with large assortments of between 60 and 72 colors. This allows the work to be drawn with direct colors and hues and avoids too many mixtures, which can deteriorate the texture of the paper and hamper the superimposing of colors or application of successive layers of color.

Selection and order of colors

Pencils must be kept in a specific order in the box. This is something the novice must get into the habit of doing, as it quickly helps you find the color you are looking for while you are drawing.

Throughout the procedure there is a continuous changing of pencils; after you use one you must always return it to its place before proceeding with the next one. That is why order is so important. Your colors should be arranged according to color ranges, from the lightest to the darkest. Neutral colors, such as earth tones, browns, greens, and grays are to be kept in a separate group or interspersed among the other two groups. Each artist will have his or her own preferred order, but whatever order you choose, be consistent. White should come at the start, and black at the end, that is, as far away as possible from the white.

Two hardnesses

There are many types of colored pencils, depending on the composition of the lead. Although with variations in percentages, the waxy type contains pigment (the substance that produces the color) bound with kaolin (a special type of clay), and wax. The most conventional variety are greasy and come in two hardnesses; the softest is the easiest to color with.

By varying the proportion of grease material in the lead's composition, two degrees of hardnesses are obtained.

worth pointing out that certain brands are renowned for their high quality, such as Caran d'Ache Faber-Castell, Staedtler or Rex Cumberland. The quality of the lead as well as the proportions of the pigment, binder, and clay vary according to the brands. The most prestigious brands identify the pigments employed in their manufacture and their resistance to light. Although it is true that with just a few colors, it is possible to achieve works of a broad chromatic range.

Fine and thick leads

There are two types of leads to choose from. On the one hand, there are colored pencils with leads of 3.5 millimeters in diameter, which are especially apt for drawing details. On the other hand, there are pencils with a greater thickness, of approximately 4 millimeters in diameter, which are very appropriate for thick and dark strokes.

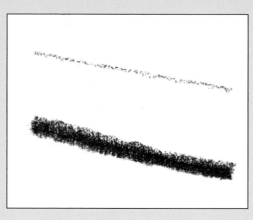

The thickness of the lead determines the breadth of the stroke.

MORE INFORMATION
• Possibilities of the colored drawing, p. 6

WATER-SOLUBLE PENCILS

Water-soluble pencils, also known as watercolor pencils, have a lead that mainly consists of colorant pigments bound with wax and varnishes, which include a soluble ingredient that makes it possible to dissolve on contact with water. They were manufactured to meet the needs of graphic designers and illustrators, and only recently have been incorporated into the fine arts field. To a certain extent, it can be regarded as a combined technique, as two media in one.

A highly flexible medium

In the hands of a professional artist, watercolor pencils can bring together the qualities of traditional watercolors and the strokes produced by the graphite pencil, which allows a wide range of exclusive effects. All the usual graphite pencil techniques can be used with them. But, because they are soluble in water, it is equally possible to incorporate watercolor techniques into the drawing. With these pencils, the artist begins by using drawing techniques and finalizes with watercolor techniques. The ease with which they are handled makes watercolor pencils an ideal drawing-painting medium that is both fresh and spontaneous, as well as an ideal drawing technique for interpreting brightly colored natural subjects.

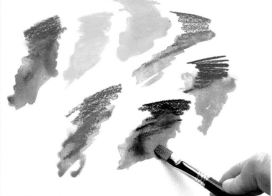

By adding water to them, the strokes give way to a spectacular effect thanks to the luminosity of watercolor.

The use of water with watercolor pencils

Conventional pencils, given their waxy composition, do not dissolve when they are dipped in water but rather repel it.

There is also a large assortment of watercolor pencils to choose from.

But all watercolor pencils, especially the high-quality type, allow all manner of color bursts. Thanks to the water, the line produced by the pencil can even be made to disappear. Normally, water-soluble pencils are applied in the same way as standard colored pencils, their softness being the only difference. Then, the water is applied over the stroke. Hard pencil strokes will remain visible after the water is applied. Once these washes have dried, the artist may apply more colors and details with pencils. When the watercolor pencil is applied on wet paper, the strokes disperse and blend.

Mixtures with watercolor pencils

Watercolor pencils add a new possibility to the mixtures that can be added to the stan-

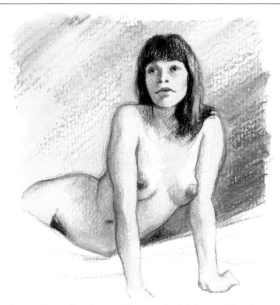

Despite the washes, the pencil lines remain visible, something that adds a very interesting effect to this drawing by Jordi Seg.

MORE INFORMATION

• Practice with watercolor pencils, **p. 54**

result. When drawing with watercolor pencils, especially when you are aiming for results similar to watercolor, it is important to choose paper that is thicker than standard drawing paper, because the absorption of the water tends to buckle thinner sheets. Fine-grain watercolor paper is the most suitable support. Many artists find a combination of transparent colors and fine lines produced by watercolor pencils and sticks so attractive that they even use them to paint large-size works. This notwithstanding, the medium is normally used with small-format works.

dard technique of superimposing tones. With watercolor pencils, the mixtures are not made separately on the palette, as is the case of traditional watercolor techniques, but instead they are carried out directly on the paper, having first applied the colors so that the paint and water blend and produce the desired

Two watercolor pencil colors can be blended together merely by running a brush over them.

The water and the brush

There are various instruments that can be used for adding water to a drawing created with watercolor pencils; however, the most common tool is the brush. The most suitable type of brushes are those made of mongoose hair, ox hair, or synthetic hair, although we recommend sable, as it is spongy with a high capacity for absorbing water and color. In addition, sable hair brushes are highly flexible, which allows the artist to open it up like a fan by applying only the slightest pressure. When the pressure is reduced, the sable brush regains its original shape with a perfect tip.

The correct brush is indispensable for obtaining good results with watercolor pencils.

THE MOST SUITABLE PAPERS

In addition to colored pencils, paper is drawing's other main protagonist. For this reason, it is essential to give this question special attention and study the most important characteristics, an important matter when choosing paper for your drawing. Indeed, the end result will vary considerably according to the weight, capacity of adherence to the surface, point of saturation, and relief of the paper you use for your work.

The weight of the paper

The greater the weight of the paper (lbs. per ream), the thicker and, therefore, the more resistant the paper. Paper that is too thin can be easily perforated by the point of the pencil, which is why the artist must take care when working on such paper.

Fine-grain paper brings out the different gradations of pencils, thereby allowing high-quality diaphanous shadings and lines, whereas thicker paper breaks the lines, lending them a more discontinuous and scratchy aspect, and allows rough shaded areas that lend the drawing a far greater atmospheric effect. When drawing on rough paper, the pig-

There are many varieties of paper, all with different tones and textures.

ment particles become stuck in the grain of the texture in the form of tiny specks of color, and this effect allows the light of the paper to be reflected, with which the colors appear more translucent.

Fine-grain textures produces soft and more diaphanous strokes.

Adherence

With the exception of coated paper surfaces, colored pencils can be used for drawing on almost any type of paper they can adhere to. Each paper has its own particular characteristic in terms of the adherence of the graphite and of colored pencils. The paper is said to be saturated when, regardless of how much you try, the tone cannot be intensified any further. This also depends on the hardness of the lead, since the softer it is, the more it colors. To achieve maximum adherence and a high degree of saturation, it is recommended to use satiny papers—a fine-grain textured paper that is hot pressed, a process that gives it its shine and eliminates all presence of grain. This type of paper is particularly suited to very detailed works.

MORE INFORMATION

- Complementary tools and materials, **p. 32**
- White on dark, **p. 66**

Attaching the paper to the support

In order to prevent the paper from becoming displaced or creased when you are drawing, it is essential to fasten the paper to some kind of firm support. This can be done in various ways: with drawing pins, paper clips, or with adhesive tape. The latter differs somewhat from the other materials in that, as well as attaching the paper to a support, it can also be used to reserve a white frame or margin around the drawing.

It is important to fasten the paper to a rigid support in order to prevent it from moving around while you are drawing.

By shading over a sheet of coarser paper, a type of granulated texture may occur.

Relief

The relief or texture of the paper support is brought out by drawing, shading, or coloring over it in pencil. In this respect, it is important to point out that the quality of the paper now available offers different textures and roughness on each side, and whose two sides can be used indistinctively, with the advantage of allowing the artist to choose the texture most appropriate for the work he or she is about to draw.

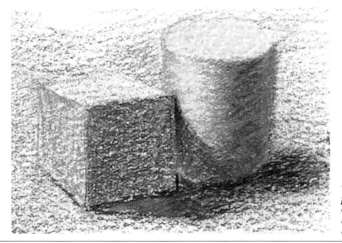

Thick, textured paper lends the drawing a more atmospheric appearance.

COMPLEMENTARY TOOLS AND MATERIALS

In addition to colored pencils, there are many accessories that artists may need if they wish to work more easily. Some are necessary but others are not. The following accessory tools are the most basic. These items are inexpensive and easy to find. You don't have to go to a fine arts store to buy them, as they can be purchased in any stationery store.

X-Acto knife

The X-Acto knife is a versatile instrument. It is used for cutting paper, sharpening pencils, or scraping leads. Some artists prefer this tool over a pencil sharpener. However, no artist should be without a pencil sharpener, since it is sometimes needed in order to obtain a uniform lead.

Pencil extender

Consists of a wooden or plastic handle into which the pencil is inserted when it is too short to hold, thus allowing the artist to use the color to the end. It is basic for prolonging the life of colored pencils and for avoiding drawing with tiny pencil stumps, which could hinder the resilience of the stroke.

Eraser

This is fundamental for drawing in general and also with colored pencils, as it is used for erasing lines and patches from the surface of the paper. Hard rubber erasers tend to damage the paper and, of course, smear applications. So, it is preferable to use soft erasers. When drawing with greasy media, such as colored pencils or graphite pencils, it recommended to always use a rubber eraser.

The X-Acto knife, in addition to its use for cutting paper, is also a suitable instrument for sharpening pencils.

Sandpaper pads

Sandpaper pads allow the pencil to be sharpened and sanded in order to obtain a more uniform stroke. It should be applied with the pencil held horizontally while at the same time turning it to allow the sandpaper to smooth the entire perimeter of the lead.

A more uniform line can be obtaining by rubbing the lead against a piece of sandpaper.

The lead of a pencil sharpened with a pencil sharpener acquires a uniform conical shape.

skin paper to protect the drawing when it is stored to keep it from getting damaged.

Fixative

Even though liquid fixative is not indispensable for protecting your standard colored pencil works, an application of this substance over the drawing will always give greater protection and a cleaner finish. A 16-ounce can of the aerosol type is the most practical.

Folder

The best option for storing, carrying, and classifying drawings is a folder. You will also need some sheets of onion-

How to sharpen a pencil

There are two basic ways to sharpen a pencil lead. We can use a pencil sharpener or an X-Acto knife. With the pencil sharpener, the tip acquires a conical shape. It is recommended to choose the type of sharpener that produces a long cone and that can be used with two thicknesses of pencils. The knife cutter, on the other hand, can be used to obtain a longer lead if required and can cut and sculpt the wooden casing to whatever shape is needed.

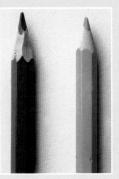

These two pencils have been sharpened: one with an X-Acto knife and the other with a pencil sharpener.

Once the drawing is finished, it is advisable to store it in a cardboard folder.

TECHNIQUE AND PRACTICE

THE VALUE OF THE LINE

Colored pencils possess certain characteristics that allow us to develop some of the most basic techniques of linear strokes. The quality and thickness of the lines, their fluidity and experimental character, as well as the way they are made to stop and start can be used to create highly effective visual illusions in the drawing. The line drawing, in addition to being the most elementary way of drawing, forms the basis of all drawing techniques.

The line drawing is the most difficult drawing style to master. It is the start of any work.

The line

The first thing beginners should do is to explore the varieties of strokes and lines, and familiarize themselves with them before starting a drawing. This can be carried out with the sharpened tip of the lead (for fine lines) and by applying the lead flat against the surface (for thick strokes).

The line drawing is the most difficult style: the artist has to resolve the colors, tones, and textures of the subject without resorting to shading or gradating.

In the hands of the experienced artist, the line itself is capable of describing almost any visual effect that the drawing can produce.

Finer and intense lines are achieved by holding the pencil, with a well-sharpened point, in a writing position.

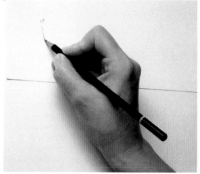

Thicker strokes are obtained by holding the lead flat against the surface of the paper.

Complementary Tools and Materials
The Value of the Line
The Direction of the Stroke

35

The thickness of the line

The quality and thickness of the line can be varied and controlled according to the hardness of the pencil, its sharpness and the pressure applied on it. The diameter of the lead is the maximum thickness that can be achieved when pressing the unsharpened pencil hard against the paper. By pressing very lightly with a sharpened lead, the stroke will be as fine as the tip of its sharpened lead. By holding the pencil at a 30 degree angle or even less, thicker lines can be obtained, whereas when held perpendicularly, very fine lines can be drawn.

The modulated line

Lines can be thick or thin, straight or undulating, which means that they allow infinite modulations. The weight and thickness of the line, its fluidness and experimental character, that is, be it continuous or discontinuous, are aspects that allow the artist to obtain very effective visual illusions. This means the line is not drawn as a simple silhouette,

The modulated line presents variations of thickness that are obtained by turning the pencil in a controlled manner.

but rather it must traverse the forms, indicate the variations of thickness of the parts of the object that are closest or farthest from the spectator, explain the texture, and whenever possible, convey the tactile sensations as well.

The best way to vary the modulation of the line while drawing is by gradually turning the pencil on itself.

A fragile lead

During the drawing process, it is important to keep your pencils in a safe place when they are not being used, while erasing, or when changing pencils. For instance, you can keep them on a piece of cotton rag or on a ledge of the drawing table where they cannot roll or fall. Although the wooden casing around the pencil protects the lead against possible damage, an accidental fall or a strong knock can damage it, and as such it may break every time you attempt to sharpen it.

When a pencil falls on the floor, the lead can break all the way down the shaft despite its protective wooden casing.

THE DIRECTION OF THE STROKE

Not only is the intensity and thickness of the line important in drawing, but also the direction of the line, that which best conveys the volume of the body of the object being drawn. Thus, the choice of the stroke will depend on the shape, structure, and texture of the subject that you are going to draw.

The stroke must convey volume

There is a basic rule according to which the direction of the line must wrap as far as possible the volume of the object represented.

The direction given to lines is indispensable for lending a correct sensation of three-dimensionality to the subject of your drawing. Thus, that the cylindrical shape of the trunk of a tree can be explained with a curved stroke in the shape of the letter C (the lines must be useful, insofar as they must express both the shading of the trunk and its roundness), the texture of bushes is represented through an agitated and superimposed stroke, and the sidewalk of a wet street, with series of parallel lines. Likewise, the combination in a single drawing of strokes of varying directions facilitates the creation of different planes and with it a greater effect of space and depth is created.

Toussaint Dubreuil, Detail of the Head of Christ. Jan and Marie-Anne Krugier-Poniatowski collection. The line must be all-encompassing in order to bring out the volume of the subject's face.

A resolute stroke

If you wish to express the volume of an object by controlling the direction of the stroke, it must never appear to waver. Otherwise you will have to go back over it, something that can lead to results that appear unnecessary and ambiguous. When defining the shape, it is best to execute it with a continuous stroke, without interruptions, than with many short and juxtaposed lines that can confuse the spectator.

Random strokes

A good way to commence a drawing is with random lines or squiggles. Even though a line of this nature may appear

A random stroke or squiggle allows the artist to draw with speed. Drawing by Oscar Sanchis.

The Value of the Line
The Direction of the Stroke
Working the Tones

37

How to hold the pencil

By holding the pencil in a writing position, that is, close to the tip, it is much easier to control the details and the pressure being applied, but this method can cause the artist to lose all sense of the whole, making it almost impossible to master the drawing as a whole. If, on the other hand, the pencil is held higher up, the artist will have far greater control of the long lines and it will be easier to extend the shadings.

By holding the pencil farther away from the tip, the artist has greater dexterity and mobility for executing broad strokes.

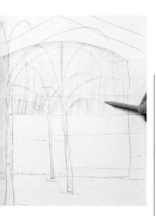

The gestural drawing aims to capture the model's inner rhythms and entails a process of synthesis.

pilot," as if carrying out a gestural stroke exercise.

The gestural drawing

This type of drawing is translated onto paper as a series of physical gestures executed with speed and in a spontaneous manner. A gestural drawing does not aim to describe the model in detail, but rather relies on easygoing and broad strokes that attempt to capture the essence of the model. In this type of drawing, spontaneity arises from brisk movements of the artist's forearm, while the subject is translated into rhythmic, dynamic lines. This technique is normally used for representing figures in action.

to have been executed compulsively and by chance, there must be a certain degree of control. Artists tend to make shorthand use of random lines and squiggles in order to include information in sketchbooks. This may be necessary when drawing outdoors and when the characteristics of the motif oblige the artist to work with haste (for instance, a landscape whose meteorological conditions are changing or a pedestrian area with a continuous coming and going of people). The random line must be drawn using the artist's intuition and "automatic

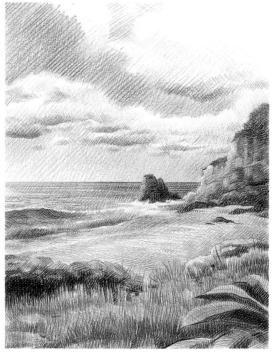

This drawing demonstrates how important the direction of the line is for describing the different planes of a landscape.

WORKING THE TONES

A major part of the interest in the drawing lies in the richness and the intensities of each tone, rather than in the brightness and variety of the colors. Another important aspect is the modeling of the forms, achieved by soft and hard strokes more than by superimposing colors. By modulating the tones, the artist is able to obtain a profound and rich selection of textures through subtle transitions of color.

Drawing a tomato

The variations of a single color are obtained by adding or reducing the pressure of the pencil over the paper. They can also be obtained by drawing with two or more colors that give rise to a single, predominating tone. The orange-colored tomato reproduced here cannot be drawn with the sole use of an orange-colored pencil; it also requires the inclusion of red and yellow. With these two colors it is possible to obtain all the hues of the tomato while at the same time drawing the volume of the model accurately.

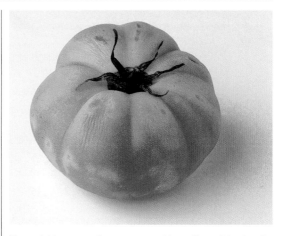

The model is a tomato that presents a red hue with a variety of tonal variations that tend to yellow.

Developing tonal variations

The initial stage of drawing the contour is carried out using a red pencil. Given that the work must be drawn from light to dark, the lightest areas of shading and the highlights must be painted yellow. Then the artist returns to the red pencil and applies new lines with it. The application of red in certain areas of yellow gives rise to orange tones that constitute the predominant color of the tomato. The effects of volume and relief are obtained by darkening the strokes of the red pencil. The use of the green is solely for anecdotal reasons,

The other intermediate tones are obtained by mixing yellow and red.

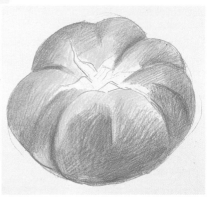

After drawing the outlines of the subject, the first applications of yellow are drawn in.

This image demonstrates how volume and substance are achieved through tonal effects.

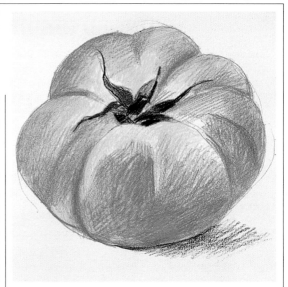

as it defines the leaves left over from the flower together with the rest of the stalk that joined the tomato to the plant.

Variations of red

In the example below, this red pepper has been drawn using only red pencils. These tones of red oscillate between carmine, magenta, and vermilion. Their combinations and superpositions enrich the complex work of the vegetable's modeling, reserving the white of the paper for the highlights. As you can see, the combination of the different reds allows the artist to resolve the modeling of the volume and the protuberances of the pepper. The white of the paper is perceived as the most illuminated areas.

MORE INFORMATION

• Shading and gradations, p. 44

Shading without lines

In order to obtain areas of uniform shading, the artist must choose the direction of the stroke and adhere to it until the drawing is completed. Each line is drawn in accordance with the previous one, maintaining the same amount of pressure at all times. In this way, the artist achieves homogenous shading and coloring. When the surface to be covered is extensive, the work must begin on a small area, then the adjacent color is added, and the process must continue successively, while attempting to hide the cutoffs.

In this case, the pepper was drawn using various red pencils of different tones.

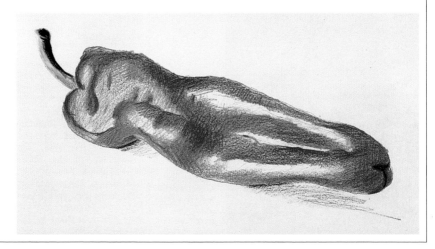

TECHNIQUE AND PRACTICE

RINGED SHADING

In the line drawing, it is not enough merely to draw the shapes with lines; they must also be explained. It is always easier to model by applying shading as a series of ringed strokes that follow the contours of the shape of the object being drawn. This method makes the model look as if it had been cut into schematic sections or rings and is a technique that is perfectly suited for drawing with colored pencils.

Ringed strokes

Ringed shading describes the three-dimensional characteristics of the shape. Drawing something merely by outlining its shape lends the object a flat appearance. In order to avoid this and achieve a three-dimensional effect, a series of ringed-shaped parallel lines are drawn that create a volumetric illusion of a cylindrical body. When bringing out the subject's relief, a certain effect of shading is obtained. This type of all-encompassing stroke is ideal for drawing cylindrical bodies or hemispheres, and as such is perfect for drawing the human body.

Ringed shading allows artists to draw the volumes of a cylindrical body based on a succession of curved or ringed strokes.

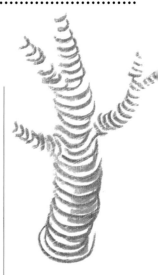

The subject: the trunk of a tree

It is not easy to find works that exemplify the contents of this section, but it is possible, on the other hand, to find several motifs that can be rendered by means of this technique. For example, the first impression of a tree trunk makes for an excellent subject. First, the model should be sketched by applying the minimum amount of pressure to the pencil. The shape of the tree clearly stands out against the vegetation in the background. Here it begins to acquire its first shadings. It is advisable to begin shading in a monochrome color that situates the predominant colors, but without determining the final color of the work. Then, the tones of the subject itself are applied successively.

Working the surroundings

The preparation of the surroundings consists of superimposing soft strokes of yellow, green, and magenta. The grass in the foreground is darkened with new tiny strokes that lend hues and density to this area. The preparation of the colors consists of soft strokes of violet and orange. These shadings provide the first impression of light and darkness, and will form the foundation of the yellowish shading.

The best way to practice this technique is to draw a tree trunk from a slight distance.

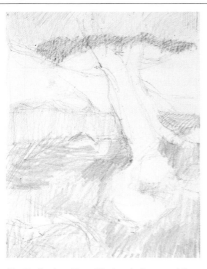

First the basic outline of the tree is drawn and then the first shadings are applied.

The direction of the stroke must at all times be consistent with the texture of the vegetation.

The ringed strokes of the trunk

Some yellow shading is applied to draw the texture and modeling of the trunk with bluish and violet tones. The shape of the trunk, branches, and roots sticking out of the ground are brought out with bluish and violet tones. The underlying tubular shapes and the way in which they cross over is clearly described with the yellowish shading on the tree trunk. The shapes need not necessarily be mechanical and symmetrical; the lines can be fine or thick, and should mold the shape of the trunk and the branches into different angles. In the modeling of the trunk, it is important to darken the edges in order to make the depth stand out, especially in the parts where the branches bend. Rather than perfect curves, the strokes must follow the protuberances and depressions of the object being drawn!

Holding on to the paper
When you are drawing, use your free hand to support the paper. Leave enough space for the trajectory that the lead must cover. The direction of the imaginary line from the index finger to thumb, parallel to the stroke, prevents the paper from creasing when pressure is being applied over it. Whenever possible, the fingers of your free hand should be kept away from the area being drawn.

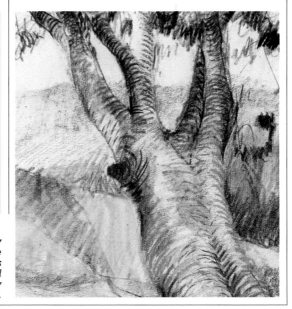

In this detail of the drawing by Mercedes Gaspar, the application of ringed shadings to represent the cylindrical shape of the trunk is clearly visible.

HATCHING

Pencils are ideal for hatching. There are many ways of going about this type of shading, depending on the result the artist is aiming to achieve. Sometimes, in the same work, a variety of hatchwork is employed and alternated with shading and coloring. It is a good idea to practice this technique, as each type of hatching lends a different appearance to the finished drawing.

Parallel hatching

This type of shading is obtained by drawing a series of parallel lines very close together in order to produce the effect of tone. The broken structure of hatching, when viewed from a normal distance, can give rise to a more vibrant quality than areas of flat colors. The artist

Two examples of hatching.

The pressure applied over the tip of the pencil determines the tone.

can also color with visible strokes, be they curved or straight, utilizing in this case their direction in order to give greater emphasis to the representation of volume of the object. Given that the white of the paper is never completely covered, the tone retains a luminosity—one of

the characteristics of this technique. By altering the distance between each line, the artist can obtain a wide variety of shading effects.

Crosshatching

This technique consists of series of parallel lines that cross each other at an angle. These lines can be rectilinear and systematic or freer and more imprecise. The closer the hatching, the darker the shading appears, an aspect that allows different tones of shading to be included in a single drawing. Crosshatching need not consist solely of straight lines. Crossing curved and undulated lines, and even squiggles, can give rise to a wide range of effects. Similarly, the tone can be modified by varying the angle at which

MORE INFORMATION

- Color mixtures (1), **p. 16**
- Color mixtures (2), **p. 22**
- The direction of the stroke, **p. 36**
- Application of glazes, **p. 46**

Two examples of crosshatching.

they intersect the transversal lines. The technique of cross-hatching demands a great deal of control in the way the lines are applied on the paper as well as the direction of each and every stroke.

The tone

A concrete tone is obtained by applying a specific amount of pressure on the paper. The greater the pressure, the darker the tone, and conversely, the less pressure, the lighter the tone. With or without hatching, each shading or color has its tone. But when hatching appears darker, it means it is denser and has had a greater pressure applied over the lead. A tonal range can be achieved by applying different amounts of pressure for each tone, but this must almost always be executed in an orderly manner. It is important to remember that the tone will be more or less manageable depending on the hardness of the pencil; the softer the medium used, the more intense the resulting tones will be.

The strokes in the most illuminated parts must be

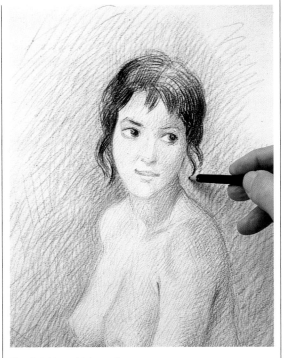

Crosshatching put into practice.

thinner and more separated, whereas in shaded areas they must be more intense, thicker and closer together. If we describe correctly the inter-

play of light and shadow with this type of shading, we will create different tonal intensities, and consequently, the effect of volume.

The problem of indentations

After erasing a pencil line, if you applied a lot of pressure to the tip, an indentation is left on the paper. By going over the area again, you will obtain a sgraffito shading in which the indentation will be even more evident. Indentations in the paper are difficult to eliminate. Nonetheless, there are techniques for reducing the problem, for instance, by rubbing the flat side of your fingernail over the indentation on the opposite side of the paper.

The groove left by an intense pencil line will appear even more visible by applying another layer of shading on top.

SHADINGS AND GRADATIONS

Shadings and gradations are the basic elements for modeling shapes and, consequently, for obtaining the effect of volume, thanks to the interplay produced by light and shadow over the surface of the object being drawn. In the same way an object can be drawn using only lines, it is also possible to draw exclusively with patches or shaded areas.

Tonal value

The line is a very interesting medium for drawing, but the range of possibilities is increased when it is combined with shading. In drawing, to evaluate is to render the tonal development of an object, to clarify and compare the tones and hues, differentiating the darkest areas from the lightest ones. Value, therefore, is understood as establishing a range of shadings that will be complete enough to lend corporeity, volume and atmosphere to the drawing.

The success of a good evaluation with colored pencils is not achieved through stark contrasts between light and shadow, but through a gradual transition between one shaded area and another.

Shading with little circles

One of the most interesting techniques for drawing shadings and gradations is using tiny circles or spirals. The technique consists of drawing tiny circles with the pencil tip applied very softly and held slightly at an angle in order to obtain whiplashlike strokes. To acquire a homogenous patch, it is necessary to work the area

little by little and maintain a steady pressure on the pencil.

Shading with little circles gives rise to a highly atmospheric gradation. The artist begins by drawing tiny circles and gradually fills the surface area of the shading while exercising the amount of pressure required to achieve the transitional effect of the gradation.

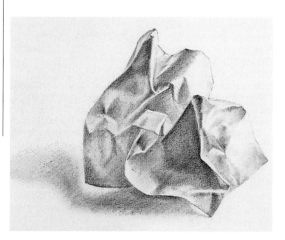

Shadings allow us to construct an object by combining tones together.

Connecting shadings

The pencil cannot be used to fill in large surfaces in one go. It can, however, be done by working in stages. If we add one gradation after another, it must be carried out in a way so that each one correctly connects to the next, by merging

A gradation resolved through the technique of tiny circles.

MORE INFORMATION
- Ringed shading **p. 40**
- Applying glazes **p. 46**

the tonal values together. To prevent sudden jumps or cutoffs in transitions between each shading, a light layer is often applied to unify them.

Gradations

The gradation is one of the most basic techniques that the novice must practice constantly. It consists of achieving a shading that includes all the tonal values of a range placed in a progressive order, that is, without abrupt leaps in tone. The gradation through shading is obtained by controlling the pressure applied on the pencil over the paper and ensuring that strokes appear juxtaposed. Nonetheless, beginners should first attempt the easier gradation technique without strokes, using a relatively blunt pencil. The texture of the paper plays as important a role in the gradation as the number or hardness of the pencil, since these factors will indicate the points of maximum light and maximum darkness.

Representing volume

The gradation allows the artist to represent the volume of an object with realism. It all boils down to making the brightest areas of the drawing correspond with the lightest tone, the color of the paper, for instance, when that is the case. Next, the gradations are made to correspond with the tonal value observed in the model.

The tonal gradation contributes to creating the impression of volume.

When a large area has to be filled in, it is normally carried out in stages. It is important to take care, as the cutoffs must not remain visible.

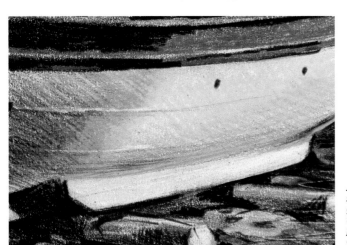

A mastery of shading and gradation allows us to draw pictures with detail as realistic as this.

APPLYING GLAZES

In many respects, colored pencils work in the same way as watercolors, that is, by taking advantage of the luminosity provided by the white of the paper. By bearing in mind that the shadings produced by colored pencils are semitransparent, they can be applied by means of glazes or soft shadings of color, which are superimposed until the desired chromatic effect is attained.

Building with glazes

Rather than mixing with glazes, we should speak of the superimposing of tones, as physical mixtures can never be total. Working with glazes may require a lengthy process, as the technique implies, gradually depositing color on the paper. It is

Superimposing increases the tone of the color.

When we superimpose three glazes of different colors, the result is a third homogenous and darker color.

important not to exert undue pressure on the pencil, as we must take care not to saturate the paper; dense shading impedes further applications of glazes.

The white of the paper

Just as with watercolors, the secret lies in making the white of the paper work to the color's advantage. Instead of applying dense layers of color, the colors should be darkened gradually, allowing patches of white to remain visible between strokes. There has yet to be an invention similar to masking fluid for use with colored pencil, and it is almost impossible to erase the marks

left by the eraser. In order to reserve areas for use as highlights or reflections, they

should be left untouched by pencil from the outset.

Color from less to more

The colored pencil technique is conditioned by the gradual intensification of tones, hues, and contrasts through superimposing layers of color, that is, painting from less to more. This allows a better handling of the values and tendencies. Otherwise, the surface of the paper becomes quickly saturated,

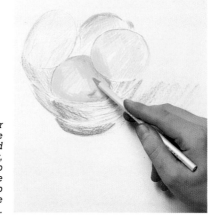

The color should be applied gradually, taking care to allow the white of the paper to breathe through.

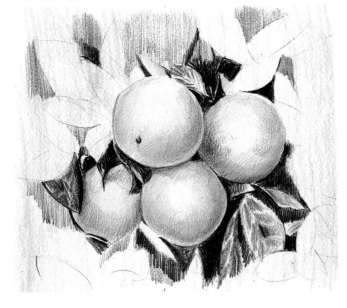

Glazes allow a very subtle work that contains few contrasts, but of exceeding quality.

impeding new applications over previous ones. In addition to working with glazes, the artist can also obtain similar effects with hatching or crosshatching.

The quantity of each color

We may create faint layers, intense layers or gradations. Each coloring presents one or various tones. These values depend on the amount of pigment distributed over the surface. In other words, these values define the quantity of color that we add to a mixture. In every faint glaze or layer, no matter how little we add to the color, we increase the intensity and opaqueness of the previous shadings.

Holding the pencil correctly

In order to spread the glazes, take advantage of the natural movement of the arm back and forth; this method allows you to work very fast. Make sure you frequently twist the pencil between your fingers, so as to get the best side for shading and to apply the tip on its bluntest side or on its sharpest side, depending on what you want to achieve.

Shadings must be applied softly and with the blunter side of the pencil tip.

TECHNIQUE AND PRACTICE

MIXTURES WITH ONLY THREE COLORS

According to color theory, there are three basic colors. They are the primary colors: yellow, red, and blue. By mixing them in pairs, these three colors give way to the three secondary colors: orange, green, and purple, and the six tertiary colors. Despite the limitations of the medium with respect to mixtures, practicing basic color mixtures will help us draw our own conclusions.

The three basic colors

The three basic colors are yellow, red, and blue. In theory, when we mix the three primary colors in equal parts, in pairs, we obtain the secondary colors. With yellow and blue, we get a secondary green. From red and blue, we obtain a purple. And, by mixing yellow and red together, we obtain a secondary orange color. In practice, it is necessary to apply each color with the same degree of intensity, in order to obtain mixtures from equal amounts of color. This theory tells us what is already easy to intuit. When observing the

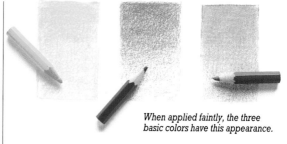

When applied faintly, the three basic colors have this appearance.

results of mixing yellow and red, we can see that the more yellow that is added, the more orange the resulting color, whereas, the more red that is added, the darker the red.

The tertiary colors

Color theory states that when we mix three parts of a primary color with one of another primary color, we obtain the tertiary colors. This notwithstanding, in practice there are

Superimposing and blending

The different colors of a model can be obtained by placing one color next to another and then either partially overlapping or superimposing them. The mixture will be more or less optical depending on the type of shading applied and the faintness of the applications and the texture of the paper. The mixture may also appear more uniform according to how the blendings are done. The most important point is to choose the best way to apply or superimpose the colors.

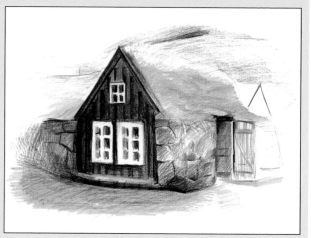

The colors must be combined gradually, through blendings or cross-hatching. Drawing by David Sanmiguel.

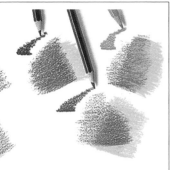

With yellow and blue we obtain green. The secondary purple appears through the interpolation of blue and red. The secondary orange is obtained by mixing yellow and red.

MORE INFORMATION

- Color mixtures (1), **p. 16**
- Color mixtures (2), **p. 22**
- Hatching, **p. 42**
- Applying glazes, **p. 46**

serious difficulties in obtaining them. It is complicated to work out the exact proportion. It is essential to bear in mind that the amount of applied color equates to the exact amount of pressure applied to the pencil. To maintain the same amount of pressure over each color is impossible. Further, even those results obtained with an acceptable degree of precision, when compared with manufac-

tured colors, appear dirty and dull.

Direct color

Over the last few years, there has been a significant increase in the variety of colored pencils on the market. In addition to current pencil sets that contain more than 40 different colors, there is also the possibility of painting directly with

the color, although we do not recommend it. As you can see below, the richness of the color is always superior when a mixture is used. Study the examples of colors and note how, working with various colors, the results appear better than by using only one color. The shadings are richer and more compact and furthermore, the texture of the paper helps bring out a certain optical vibrancy from the different colors.

Note the difficulty entailed in creating a brown color by superimposing tones.

When drawing, note how the color derived from the mixture is more interesting than the same color applied direct.

PRACTICING SHADING WITH STROKES

The mixture of colors based on the superimposing of hatching is achieved by diagonal shading, applying parallel series of lines, or filling in space with much richer tones and textures, which brighten the drawing.

Shading techniques with pencils

The exercises that appear on the following page provide a demonstration of the different types of shading that can be obtained by combining three colors: blue, red, and green. We begin with blue. Then, when adding the second color, red, the two colors mix together optically, creating a second tone. Next, by adding the third color, the depth of the tone is greater still. In this way, we can observe: diagonal shading (a), simple hatching and cross-hatching (b), divisionist or pointillist shading (c), shading with little circles (e), and, finally, shading on thick textured paper (f). Note that despite the different combinations of strokes, each color retains its own identity.

| MORE INFORMATION |

• Color mixtures (1), **p. 16**
• Color mixtures (2), **p. 22**
• Hatching, **p. 42**
• Mixtures with only three colors, **p. 48**

Expressing depth with the strokes

There are two basic directions. In parallel perspective and oblique perspective, which are the two most common types of perspective, the vertical direction poses no problem. In order to form the shading, we require another direction, one that will be related to the horizontal aspect. In regular polyhedral objects, the directions are given, on each face, by the line that converges at its corresponding vanishing point. In cylindrical or spherical objects, the direction of the stroke must describe how an imaginary plane cuts through the object by the horizon line.

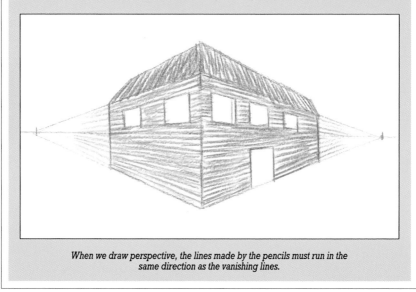

When we draw perspective, the lines made by the pencils must run in the same direction as the vanishing lines.

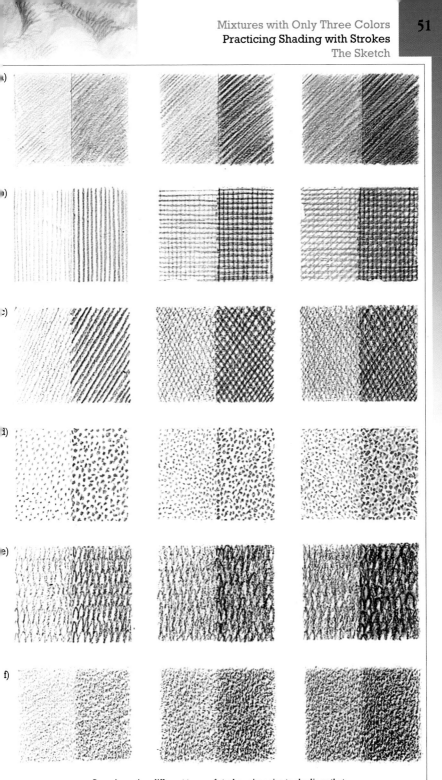

*Superimposing different types of strokes gives rise to shadings that
present varied textures and lighting effects.*

THE SKETCH

Technically speaking, the sketch is the first step toward the drawing. It is a line drawing that the artist creates in order to sketch a brief outline of all the shapes composed by the model, drawing forms and proportions, as well as the most important details and starkest shadows.

Fast sketches

When attempting to capture a movement, the line sketch is the fastest and most suitable means for expressing the spontaneity of the view. The tremulous lines that are so typical of sketches possess a dynamic characteristic that is always the product of a fast execution. Sketches do not call for a previous scheme, as the sketch is already a schematic drawing. It is a good idea to begin with a rough calculation of sizes and proportions. If you have more time to draw, the

The best way to begin sketching is by observing the model schematically and in synthesis.

fundamental lines should be established first, followed by the background and the horizon. Then the lines of the vertical planes and the outline of the objects must be worked out. Finally, the planes in shadow must be gone over, with directional strokes. The sketches of the model are drawn with a loose stroke. To master this type of fast and spontaneous sketching, constant practice is required in order to learn how to resolve the typical errors that arise during sketching.

The intention of the stroke

When drawing the components of the model in pencil, we need a guide or a framework. The master lines of the sketch must be drawn faintly, so that the contours can be rectified and corrected, and even more so when drawing with colored pencils (which are

What colors to use?

Attractive results are obtained most easily from subjects with abundant color. In large part, the success is due to the wide range of colored pencils available to us. The colors we choose are those that will be used in a direct manner according to what the artist sees in the model. It all boils down to observing the components of the model. Here we examine our selection of pencils and, by comparison, choose the ones that will best represent them, by color and by tone.

It is advisable to have a broad range of colors from which to choose at any moment.

not as easy to erase as graphite pencil). Of all the lines, the contour of the object is the most important. The stroke, when working with this drawing medium, tends to be somewhat undecided; nonetheless, with practice, you will acquire more confidence and artistic flair.

Solidity

There are various aims of the sketch. We have already seen the important role of the line sketch, whose main aim above all else is to capture the movement, gesture, and essence of the moment. But the artist may also be interested in

The direction of the stroke must help to explain the textures, the light, and the space of the works within the frame. Sketch by Oscar Sanchis.

Constant practice in fast sketching is required in order to attain agility. Sketch by Oscar Sanchis.

sibilities of pencils, adjusting the pressure and working with the lead at an angle, thus filling in the shaded area and adding on top of them their tonal value by superimposing one layer over another.

reflecting the solidity of the subject. In such case, he or she can choose from a sketch based on lines that model the subject, that is to say, lines that create the volumes and areas of light and shade. Therefore, after observing the model and drawing a preliminary draft, the artist can begin shading the main masses by taking advantage of all the pos-

Always have a sketchpad with you; it only takes five minutes to draw a sketch like this one.

PRACTICAL EXPERIENCE WITH WATERCOLOR PENCILS

Traditional drawing techniques are employed in order to obtain the foundation of the drawing. But watercolor can then be incorporated using the brush as the drawing tool. The fluidity and ease of handling watercolor pencils makes them a flexible and an ideal medium to work with when interpreting natural subjects.

Possibilities of the medium

Watercolor pencils, in addition to offering a stroke similar to that of traditional pencils, can be mixed with water in order to obtain a more fluid and pictorial appearance. They can be used to fill in large areas or background by first rubbing the stick or pencil and then making it uniform by running a brush dipped in plenty of water over the top. The result is an image that oscillates between the drawing and the painting.

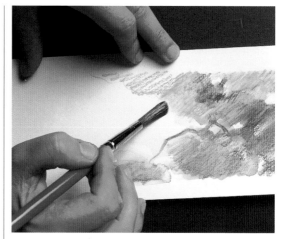

A wet brush is used to blend the colors, all the time making sure that the strokes remain visible.

Washes and strokes

The best method for painting with watercolor pencils is to work fast and with assurance. In this way, the colors do not mix too much and they do not blot, retaining the original pencil strokes. By running the brush over the pencil line with

abundant water, a simple shaded area is turned into a wash. The water does not blend the colors completely, but rather, in addition to providing a uniform wash, it respects the hatchwork made by the pencil and gives way to a curious texture that combines both stroke and wash. It is important to carry out many trials, as painting with watercolor pencils

requires a certain amount of practice, because if you add too much water, the surface will become drenched and will run; on the other hand, if you add too little water, the colors will not blend properly.

Multiple layers

Watercolor pencils allow interesting textures to be

MORE INFORMATION

• Water-soluble pencils, **p. 28**

Note the differences between the first washes and the third, which were drawn with watercolor pencils, and the second and fourth, done with watercolor.

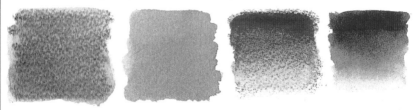

There is no need to persist with the brush, one sweep is enough to make the water run.

a fuzzy stroke, as well as increase the likelihood of damaging the paper.

obtained by adding various layers, that is to say, by combining dry strokes with diluted ones. Nonetheless, when adding a shading of dry color over a dilution, the artist must check that the paper is completely dry beforehand; otherwise the dampness will soak and soften the tip of the pencil, which will produce

By rubbing with a dry brush over a wet wash, we can open up white areas over the drawing.

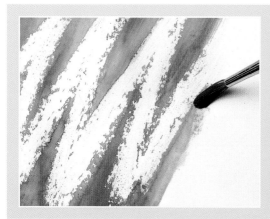

Reserving highlights

Reserves are important with watercolor. We must reserve them from the outset in the foundation of the drawing. The most notable highlights, such as those of glass and metal objects, can be reserved with a conventional white pencil or even with white wax crayon, as they repel water.

In order to carry out a negative effect, one only need draw with a wax crayon or white pencil and then extend the wash on top.

TECHNIQUE AND PRACTICE

LOVE OF BOTANY

During the 17th and 18th centuries, natural-style drawing acquired great importance due to the growing interest in the natural sciences and, above all, in botany, the discipline that studies and classifies the vegetable world. The meticulousness with which colored pencils can be applied has turned this medium into an invaluable ally of admirers of flowers.

Drawing close up

The motif of flowers is one of the most apt for drawing with colored pencils. It is important to study flowers from close up, in order to appreciate better the velvety textures of the petals, the details of the stalk and the capricious shapes of the leaves. Fill your notebook with sketches to study them. The more in-depth the observation, the better the results will be.

A progressive action

The description of a floral motif through the color drawing is a progressive procedure of defining the different shapes, always working from the most basic to the detail. The complex-

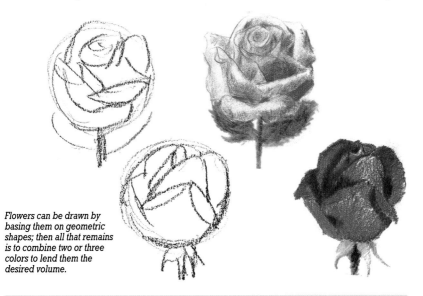

Flowers can be drawn by basing them on geometric shapes; then all that remains is to combine two or three colors to lend them the desired volume.

Scientific expeditions

Throughout the 18th century, scientific expeditions often used specialized draftsmen, who were capable of executing exhaustive reproductions of newly discovered species. Among the most

outstanding artists of this new botanical art were Pierre-Joseph Redout, Claude Aubriet, and Samuel Dixon. The drawings had to be extremely exact, so that it was possible to distinguish perfectly all the morphological details of the plant.

Claude Aubriet, African Cinara. Musée National d'Histoire Naturelle (Paris, France).

It is necessary to draw with great care, adjusting to the maximum for the formal particularities of each species. Drawing by Esther Rodriguez.

ity of botanical drawings is gradual and depends on the development of the work.

A world of hues

A wealth of tones can be achieved with colored pencil. A single color can be worked in all its tonal variations, and each one of them can be shaded with thousands of colors in varying intensities. When painting flowers this allows them to be rendered in all their luminosity and color.

How to lend volume

It is important to distinguish between painting with flat colors and drawing tonal values. This does not imply that flat color cannot express volume, but rather it is recreated by juxtaposing strongly contrasting complementary colors and not, as often occurs in tonal treatments, by gradating. The effect of volume depends on the position of the model with respect to the light. In this way, the stalks of the flower can be painted based on a single color; by incorporating dark tones in the areas in shadow and blending them with the first color, we begin to bring out the value, and, if we add some highlights and merge them with the base color, the tonal value will be complete.

In flower motifs, and in plants in general, textures have an especially important role. Drawing by Esther Rodriguez.

A tonal background lends greater interest to the drawing and prevents it from being confused with a mere botanical study. Drawing by Esther Rodriguez.

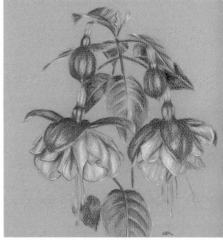

ANIMALS WITH COLORED PENCILS

The artistic representation of animals is an especially popular subject among colored-pencil drawing enthusiasts. Nowadays, we can find a multitude of artists who, due to their profound fascination for nature, flora, and fauna, have taken up this theme as a main subject of study in their work.

Textures, strokes, and colors

The diversity of textures and colors of animals constitutes in itself an interesting challenge for the artist. In order to tackle this motif, the artist has to master several specific strokes; as you will see, it is not the same to draw the scales of a snake as it is to draw the plumage of a bird or the short shiny hair of a bull or the fluffy fur of a cat. Depending on the case, the artist will have to draw strokes of juxtaposed lines (in animals that have fur or abundant hair), with splashes of color or with shading based on little circles (for drawing scales), or with smooth and blended shadings (for soft-haired and velvety animals such as dolphins and seals). Therefore, it is important to experiment with the medium before deciding which technique is most apt for the subject.

The intensity of the color and the direction of the stroke are decisive for painting the plumage of certain exotic birds.

The texture of the hair is achieved by juxtaposing numerous tiny and precise strokes to represent the tonal values of the coat.

Using pure color

When referring to the overall shape of animals, perhaps birds have the most varied colors. There are also monochrome species, such as flamingos, or brightly colored birds, such the macaw or the peacock, whose variety and contrast are fascinating. The main priority of any painting is the visual intensity transmitted by the color. And this intensity can be brought out through the use of pure colors. Pure color possesses its own visual force, which the animal artist can

The mixtures of pink, sienna, and ochre achieve an excellent result in animal flesh colors.

which emphasize the effect of relief of the tufts or feathers. A short-haired coat depends on the position of the animal and of its movement; it may be seen as a smooth surface or may appear as a mass comprising light and dark tones. An animal that has a profusely marked skin may be difficult to draw, as the shape may be dominated precisely by these markings. The use of colored pencils allows the artist to take the drawing of animals to the height of photographic realism.

exploit, provided he or she is ready to sacrifice the pure realism of the representation. Completely flat colors do not create such a sensation of relief and volume as a value painting. Painting with flat colors means that the shape must be highlighted through contrast, bringing out the contours, although not the relief nor the sensation of a third dimension.

Painting hair

One of the artist's primary concerns when painting animals is the texture of the hide. In order to draw the coat or the plumage of animals, there are two main considerations to take into account: the orientation of the stroke when reflecting the texture and direction of the hair, and the interplay of highlights and shadows,

Care must be taken with the direction of the stroke and ensure that it always envelops the shape. Drawing by Vicenc Ballestar.

The importance of the stroke

The impact of energetic strokes also comes in handy for suggesting the movement of a figure. Sometimes, a looser style, with more gestural lines, insinuates movement better. Long and sinuous strokes, gestures drawn that capture the movement of an animal with great speed, already imply a certain effect of mobility. This means that a fast drawing or painting style is required to capture with speed the strokes that indicate the fleeting essence of movement.

The vigor and strength that an animal transmits must also be present in the vigor of the stroke and the saturation of color. Drawing by Vicenc Ballestar.

SURFACE TEXTURES

The stark contrasts between smooth surfaces and more irregular and abrupt surfaces are largely responsible for a greater feeling of solidity and vitality in our drawings. Knowing how to correctly paint tactile qualities of objects is essential if the artist wishes to impress the viewer; to do this it is necessary to pay attention to the position of the highlights and reflections as well as to master the modeling technique.

The modeling

The secret to correctly reproducing the variety of textures and surfaces of materials lies in the modeling. Modeling is the technique of expressing the changes of light and color and reflections over the surface of objects. In other words, the modeling gives objects the effect of volume and lends them their characteristic quality and surface texture. We can say the artist models when he or she imitates in two dimensions what the sculptor does in three: lend

To model an object is to express the changes in light and shadow on an object.

body to the subject and make it present.

Smooth surfaces: metal objects

If we wish to render a smooth surface texture, the shadings must be executed with great softness and progressively, avoiding at all times the presence of pencil strokes and intensifying the values from new transparent glazes. A smooth appearance can be achieved with a fuzzy, unfocused contour. Since there is no specific color for painting metal, the metallic surface is simulated through a successive color gradation, combining it with the reflections of the light. The effect of metal is attained through patches and tiny gradations that can extend from the darkest black to the most intense white, passing through carmine, green, earth colors, sepia, and all types of yellows and reds (the latter being the most commonly used colors for describing the color of metals).

Highlights

Highlights are tiny reflections from the source of the illumination that, like shadows, can help you to bring out and emphasize the texture of an object. When the smooth

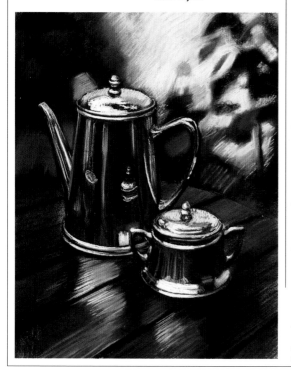

Metal objects tend to reflect other nearby objects on its surface. Drawing by Miquel Ferrón.

surface we are drawing is shiny, a new variable is added to the work of obtaining the values and the modeling of the work; the light values that are not accidents in the volume but a reflection of light, are paramount for transmitting the tactile sensation of a smooth and shiny surface. In the colored pencil medium, the technique of opening up white areas with an eraser or adding highlights with white is rather fruitless, as is the case in other drawing media. Therefore, the best advice is to leave the areas untouched.

The reflections must be reserved from the outset. For drawing with pencils there is no equivalent of the masking fluid used in watercolor.

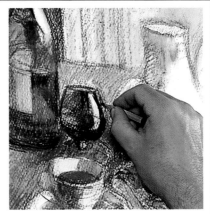

Creased textures: drapery

The subtle variations of light and shadow help to express creased textures or their relief. In these cases, it is not necessary to cover the entire object with creases drawn with irregular and shaky strokes, because it would appear too disconcerting; it is sufficient enough to suggest certain areas of relief, without aiming at photographic realism. Often, it is more interesting to suggest than to excessively complete a drawing. The folds and creases of drapery are far more intricate than any of the textures mentioned previously. They describe curved forms and sudden gradations that are modeled with less uniformity than in spherical shapes.

The case of glass

In order to draw glass, the first thing one must bear in mind is that it is a colorless material, with the logical exception of colored glass. Therefore, both the shape and the volume of the bodies directly behind glass will be visible through its surface, particularly objects seen through glass, which are deformed to a certain degree. The surface of glass can present a multitude of highlights and other nearby objects can be seen reflected on its smooth surface, which acts like a mirror.

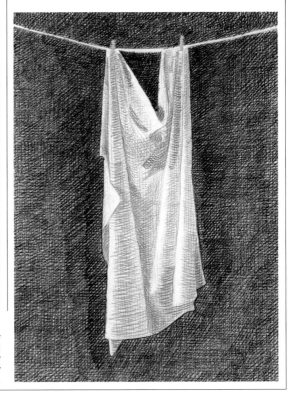

With lateral lighting, drapery creates a texture based on creases with outstanding shadows. Drawing by Gabriel Marten.

HOW TO BEGIN DRAWING

The first lines that are drawn on the paper are the most important, as the preliminary drawing determines the framing and constitutes in itself a first appraisal of the subject's tonal value. The choice of stroke and the initial color, always with neutral tones regarding the model's chromatic tendency, will determine the value of the work and the pictorial end result.

Studying the composition

Once you have visually studied the model and have discovered its structure and order, that is to say, the arrangement of each one of the elements that comprise the model, it is sketched before the drawing itself is begun. For this reason you must choose a soft colored pencil and draw the first lines by barely touching the surface of the paper. These lines should be almost imperceptible. In the construction process, the artist first concentrates on the overall form and then, the elements and their details. Once the basic outline of the model has been sketched, the drawing can be started with the focus turning to work on the shapes of the objects.

The preliminary drawing

Once the soft outline has been sketched, we can proceed to the preliminary drawing. Said drawing consists of a more elaborated sketch, which

A sketch prior to the drawing is useful for maintaining the relationship of the proportions between the objects.

After blocking in the drawing, the shadows are colored softly, with the same color used in the preliminary sketch.

Erasing

Occasionally, during the initial stages of the drawing, some of the lines need to be erased. So it is a good idea to always apply the tip of the pencil softly. With colored pencils, the faintest strokes can almost be entirely erased, whereas darker strokes will always leave a mark and, if you attempt to color over them, the result appears dirty. Therefore, avoid corrections as much as possible.

When erasing, hold the paper down firmly. The motion of the eraser must not be allowed to crease the paper.

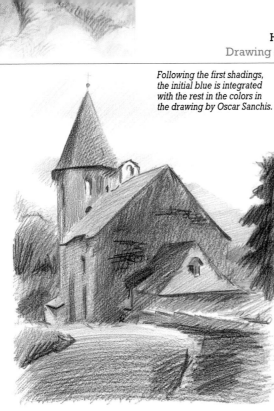

Following the first shadings, the initial blue is integrated with the rest in the colors in the drawing by Oscar Sanchis.

simpler than it might seem at first. Then, so as to achieve a high degree of realism, a good deal of organization is required in the search for the tones of each of the areas of light on the model.

How to work on broad areas

In every drawing the artist has to find the overall harmonic tone (ochre, sienna, blue, etc.) that will be the most suitable for coloring the broadest areas. After extending the first shaded areas, which help cover the whiteness of the paper, the details of the elements are gradually brought out. The most frequent way to start is to outline an object and proceed until the entire area is filled in, avoiding shading or intense coloring in the first layer in order that cutoffs do not appear too visible. Then, we superimpose transparent layers, overlapping them until the suitable tone has been obtained.

must never be done with a graphite pencil, since colored pencils and graphite pencils are largely incompatible media. There are two basic reasons for this: in the first place, because colored pencils slide over the grease of the graphite pencil; and second, because pigment graphite separates quite easily from the paper and tends to blacken the mixtures of adjacent colors.

We recommend you begin your drawing with a colored pencil, preferably a medium tone. The most commonly used pencils by artists are violet, blue, or an earth color. The reason for this is that these colors are easy to integrate within the overall color scheme.

Detailed drawing

In order to achieve a good result with colored pencils, it is absolutely essential that the initial sketch of the drawing be executed with care and

total meticulousness. You will see that, by starting from a more elaborate preliminary drawing, the process will be

With the first harmonizations of color, we begin covering the white of the paper and adjust the tone of the base over which we will work.

TECHNIQUE AND PRACTICE

DRAWING ON A COLORED SUPPORT

The work acquires interesting painterly connotations when it is drawn on a sheet of colored paper. The color of the paper is merged into the drawing and becomes part of the same. In this way, the artist can achieve effects that highlight the third dimension thanks to the contribution of contrasted light and dark strokes, which provide a different general harmonization than that drawn on a white sheet of paper.

The color of the paper

Colored paper is ideal for use with colored pencils. In addition to serving as a perfect base for drawings that contain white highlighting, the color harmonizes the work and allows the modeling of the forms to be executed with greater precision. In this sense, white paper often poses a difficulty with establishing criteria in respect to the tones of the colors, since it can be discouraging and bring about the effect of simultaneous contrast. The majority of colors appear darker on white paper than when applied on a colored surface. This is something that must be taken advantage of.

Medium tone papers

Neutral colors, such as grays, ochres, and bluish tones, are on the whole the most pleasant colors for drawing with colored pencils, as they provide a

The darker the paper, the greater the emphasis of the highlights through contrast.

color that can be harmonized with most colors and can emphasize to the same extent both the light and the dark colors. The color of the paper remains visible between the pencil strokes and produces an interesting neutral effect, which also has a harmonizing and unifying effect on the work.

MORE INFORMATION
• Nighttime scene on colored paper, **p. 92**

Highlights with white

When we draw on colored paper, the medium tones present certain limitations imposed by the paper itself, something that poses a problem for the subtle modeling of the shapes. This inconvenience can be overcome with applications of very saturated white color; the contrasts between highlights

Take care to choose colored pencils that will present enough contrast with the color of the paper.

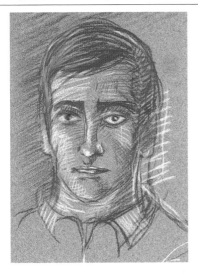

White highlighting on colored paper allows a heightened effect of volume.

Watercolor grounds

If you wish, you can prepare your own tonal grounds to draw on. This is done by applying various washes superimposed on one another with a large brush or a sponge, until the paper acquires a uniform tone. The aim is to mitigate the white of the paper with a uniform medium gray, which must be dark enough to allow white pencil strokes to stand out on it clearly and, at the same time, it must be light enough to allow the most intense lines to be made out.

You can create your own tonal grounds by tinting the white paper with watercolor. A sponge comes in very handy as a substitute for a brush for this task.

and shadows are so sharp that the drawing acquires another interest. The highlight has the greatest effect when it is not dispersed all over the paper, but appears only in those parts of the drawing that help to increase the contrast and, with it, highlight the sensation of volume.

The most frequently used tones of colored paper

The most frequently used tones of colored paper are ochres, umbers, reds, matte greens, or grays, although there is really no restriction in choice. There is only one point to have in mind when deciding on the color of the paper: cool color papers, such as green or blue, lend the drawing a cool sensation, whereas warm tones of paper, such as orange, red, yellow, etc., produce a greater effect of warmth.

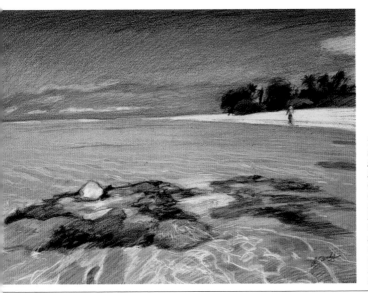

The color of the paper should not be filled in entirely; part of it should be allowed to breathe through the subsequent applications of color. Work by Oscar Sanchis.

TECHNIQUE AND PRACTICE

WHITE ON DARK

The positive effects of working on a dark colored paper will be seen in the following exercise. The drawing done in color pencils takes on interesting painterly connotations when the artist knows how to combine them on a dark colored background; the highlights appear more intense and the chiaroscuro is intensified, giving rise to an interesting display of high-quality luminous and expressive effects.

Painting light

The model for this exercise comprises various architectural structures with clearly differentiated areas of light and shadow. The subject of buildings may sometimes appear complicated. However, as you will see, the technique leads to the simple suggestion of the ornamental motifs. First the artist outlines in white pencil each one of the buildings, looking for the areas of maximum light, extending some shadings over the illuminated parts of the facades and leaving the areas in shadow untouched. Therefore, we will only paint the highlights and leave the color of the paper to represent the shadows.

Correct architecture

In this first stage, the perspective and the proportions must be absolutely correct. A drawing like this is the result of careful observation. It must be constructed slowly and with

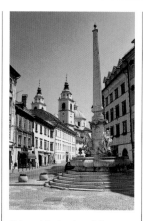

This architectural model presents effects of contrasted light.

successive layers of superimposed color, so as to reduce the risk of making a mistake. First the general structures are

drawn, then the most illuminated parts are filled in. The work must be monochromatic; the white pencil must progressively gradate the intensity of each tone of light with successive superimposed shadings. In this phase, the intermediate tones can already be clearly discerned. The shaded areas are still barely untouched.

Adding color

Adding local colors gives enough counterpoint to the drawing to bring the foreground nearer and to better define the intermediate tones. In the sky, white is superimposed with shadings of yellow, green, and blue that lend it an unreal and magical appearance.

Drawing softly

It is important to draw the main structure with faint lines. The shadings in the initial stages must be applied fast and allow the volume of the bodies to be initiated through highlighting. The shadings drawn with white pencil must be progressive.

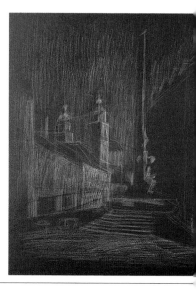

By shading only the illuminated parts of the facades, the model of the sketch appears to glimmer.

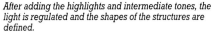

After adding the highlights and intermediate tones, the light is regulated and the shapes of the structures are defined.

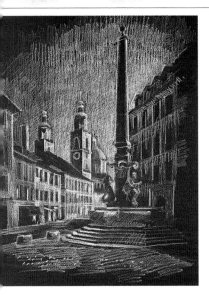

The colors added must be unsaturated and very selective.

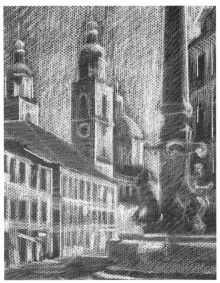

The orange tones of the obelisk bring the foreground closer to the spectator and provide a link to the other areas of the drawing. In the darkest areas of the picture, the color of the paper is predominant; in the shaded areas, we can barely make out the strokes of cyan blue, which contribute to lending intermediate values to the shaded areas.

A photographic image

Drawing on this type of colored paper with light colors is traditionally associated with the chiaroscuro effect, whereby the contrast is highlighted totally or partially between the objects and the dark color of the background. The end result is a vaporous drawing, in which the effects of light illuminate the atmosphere. The intentionally dark margin around the work gives the finished work the appearance of a photograph from the beginning of the 20th century.

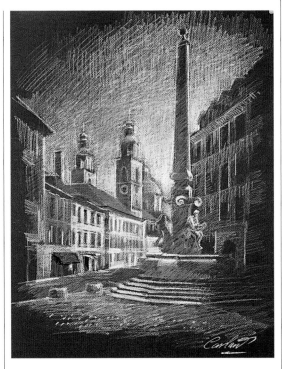

The illuminated areas are filled with warm colors and the shaded areas of the facades contain cool colors.

STILL LIFE WITH WATERCOLOR PENCILS

Given that this medium is water soluble, watercolor techniques can be incorporated into the draw-painting. In principle, these pencils are applied with drawing techniques. It is not necessary to add much color because the layers must be faint. The drawing finishes with watercolor techniques, incorporating the the brush as a drawing instrument.

The foundation of the drawing

To begin, a highly detailed sketch of the still-life model is executed in turquoise blue. Next, the darkest shadows are sketched with cobalt blue, ensuring that strokes are applied in the same direction as that used from the outset.

It is a question of drawing in the same way as a pencil drawing, without thinking about the watercolor part. Thus, we obtain the value, the modeling and the shading in the usual way, applying the pencil very softly from less to more.

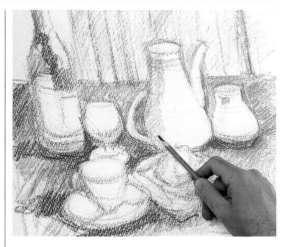

First, the model must be shaded in the traditional manner, without taking into account the effect of the watercolor.

Intermediate stage

This is what the first stage looks like, before applying water and brush.

Note how the areas of the tablecloth that will later be painted with watercolor have

a greater regularity in the strokes and shadings. There is no need to apply much color; it is better that the layers are tenuous. Before the water is added to the strokes, the

highlights are reserved with a little stick of white wax. Wax, as you known, repels water and, therefore, will protect these areas from becoming stained.

We mark out the shaded areas with slightly more saturated strokes.

The washes fuse together the different areas of color, lending the drawing a more pictorial aspect.

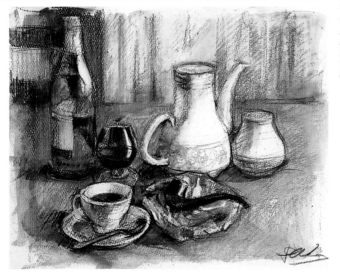

The final result of this work by Miquel Ferrón shows the perfect unity between washes and strokes.

Washes

Once all the color has been applied with shadings, everything painted must be bathed. Using a brush dipped in water, the tone of the color on the paper is blended and adjusted. The brush loaded with clean water is applied over the shaded areas. A large round sable-hair brush is used for this task; it must be drained of surplus water in order to avoid drips. Rather than rubbing the brush over an area, which could dilute the color excessively, it must be allowed to glide or flow across the paper. The watercolor process must be executed in the right order: working from the dark areas toward the light ones.

Combining washes and strokes

To the finished drawing, the watercolored areas must be combined with shadings and gradations in which the strokes still remain visible on the texture of the paper. Then, when the areas of watercolor have had time to

dry thoroughly, the final touches are carried out with pencil strokes (correcting contours, defining shapes,

obtaining greater contrast), which must be evident in the finished drawing.

The path of the water

When working with watercolor, it is necessary to look for the easiest and most direct paths for the water, making sure the brush does not dry, with the aim of obtaining a flat wash without cutoffs. New areas cannot be gone over with water until the previous ones have had time to dry properly. Avoid contact between wet areas, otherwise the washes will blend and the colors will expand uncontrollably.

The brush must be applied with plenty of water in order to find a reliable path.

TECHNIQUE AND PRACTICE

THE DISCONTINUED COLOR TECHNIQUE

The discontinued color technique is very effective with colored pencils. The procedure consists of superimposing juxtaposed strokes, which gives rise to great chromatic vigor over the surface of the work. The aim is to achieve free strokes of complementary colors, creating a discontinuous texture that allows the underlying color to show through.

Warm and cool tones

The subject of this exercise is an interesting rural village scene that includes a succession of tiled rooftops. The drawing will be executed with a daring range of colors, which plays with the contrast between the warm colors of the roofs and the cooler colors of the facade in shadow. The artist has chosen a sheet of yellow paper, as the effect of discontinued color can be highlighted further still using the colored paper, which will remain visible between the stroke shadings.

MORE INFORMATION
• Feathering, **p. 78**

The first step is the sketch. Violet is used because it is the complementary color of the yellow color of the paper.

Background colors

The work begins by covering the rooftops with an orderly succession of hatching in orange and the precipice and facades with a layer of violet. It is important to note that these two colors are diametrically opposed in the color wheel. The aim of these applications is to obtain an overall starting point for the colors and half-light base color that follow, over which both light colors and dark colors can be applied.

Juxtaposed colors

The juxtaposition of colors is carried out gradually; greens, yellows, violets, blues, and ochres share the same

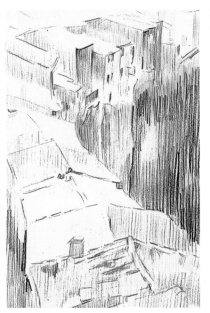

A succession of parallel strokes covers the background in order to create the intermediate tones.

More saturated tones are added to the drawing, while always bearing in mind the contrast of complementary colors.

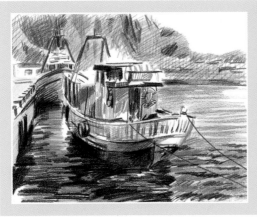

The search for expressiveness

The effect of discontinued color takes maximum advantage of the juxtaposition of complementary colors, in order to achieve the maximum color contrast, a vibrancy in the work, and with the aim of conveying energy, vitality, and force. This procedure was extremely popular among the fauvists.

The intense and saturated strokes of Oscar Sanchis lend the drawing the desired vibrant effect.

space, in which a satisfactory optical effect is obtained. The maximum contrast is produced between the strokes of completely saturated complementary colors, which lend a very energetic sensation to the motif. From the right distance, the complementary color strokes are interpreted by the spectator as a single color. The construction of the drawing is based entirely on lines, without shadings or gradations.

Respecting the background

The final applications of color must be drawn by applying pressure to the pencil to obtain saturated strokes and sharper contrasts, which allow us to define the contour of the shapes and accentuate the volume. The entire surface of the paper must not be filled in. Leaving the natural color of the paper visible in certain areas may help to unify the drawing, imbuing the work with luminosity and quality from the color of the paper. Working the surface excessively will only make the work appear boring and inert, thereby annulling all spontaneity.

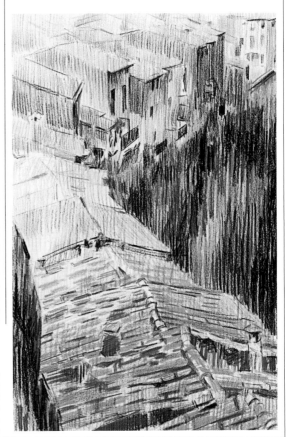

The depth of the work is highlighted with more intense colors in the foreground and the more attenuated strokes in the facades of the background. Drawing by Oscar Sanchis.

ARCHITECTURAL DETAILS

Architecture is one of the most interesting subjects for a drawing. The intrinsic beauty and ornamental motifs of certain buildings can make them the sole protagonists of the work. The painterly possibilities of colored pencils allow almost any type of architectural structure to be rendered, regardless of how complex it may seem. Nonetheless, this genre demands great skill of the artist to resolve the question of perspective, the relief of the facades, and the contrasts of light and shadow.

A Gaudí park bench

We will use as our model several modernist park benches in the Park Güell, the work of Antoni Gaudí in Barcelona. This exercise will allow us to put into practice the differentiation of planes by separating them according to depth. The foreground, occupied by the nearest bench, will be given much more definition than those in the middle ground and background, which will gradually lose all definition as they recede into the distance, although the colors used will be the same for all the benches; the only difference being that the pressure applied on the pencil will be varied, as well as the sharpness of the details. Both the time of day and the direction of the light are fundamental aspects for emphasizing the three-dimensionality of architectural structures.

A first appraisal

Using a blue pencil, we draw the benches and the balustrade and then define all the areas of shadow using the same color. Directly afterward, we darken the entire background in order to highlight the main subject. A soft stroke provides a foundation for the decorations on the wall. It is a question of coloring in all the areas of the drawing, as the aim at this stage is to obtain a first appraisal of tones so as to begin to add values with greater precision. It is a good idea to draw the details of the mosaics by leaving white space between them.

Details

With very faint strokes, and by following the direction of each one of the curved walls of the bench, we add color that separates the different planes.

As always, the sketch is drawn with blue, indicating from the outset the areas of shadow.

The detail must be combined with more open spaces and just the right amount of decoration.

The areas of detail are contrasted with the more neutral ones. This drawing requires a variety of ornamental motifs. Often, the suggestion of a texture, motif, or detail is enough to transmit

Thanks to the waxy consistency of the pencils, a razor blade or a knife can be used to open up white areas over intense shadings.

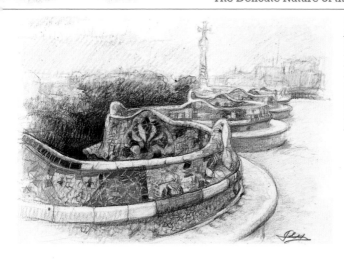

Controlling the pressure applied on the paper is fundamental for representing the scale of the different planes as they recede into the distance. Drawing by Miquel Ferrón.

the mosaic effect of the benches. The light and shadow are used to obtain the modeling of the solid structure of the bench and simulate, by fading the color in the distance, a clear sensation of space and depth.

Highlights and shadows

In the details of the background, dark colors are tonally equated with light colors in the foreground. As the drawing is defined, more intense colors are added. The dark areas are drawn with saturated cross-hatching of carmine and blue, which give way to a dark violet color. The intermediate tones are created with a judicious intervention of ochre.

Varying the point of view

Knowing how to choose the best possible point of view and the framing is indispensable for achieving an interesting architectural representation. If you draw a tall building from a low point of view and close up, the result may be impressive, thanks to the curious effect of perspective which makes the building appear to fall back and the facade appear to vanish at one point. If we draw the same building from a high point of view, the lines run downward. In the same way, we must choose the right framing; sometimes, one part is enough, a facade, a corner, or a balcony, for finding interesting subjects.

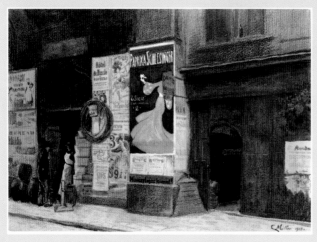

Carl Müller, Vienna Street. Watercolor, 27 x 37 cm. Historisches Museum der Stadt (Vienna, Austria).

THE DELICATE NATURE OF THE PORTRAIT

Of all genres, the portrait is the one that instills the most respect among amateur artists. The keys to a good portrait consist of observation, good drawing skills, a certain interpretive capacity of the model, and a mastery of the medium. Colored pencils are the most appropriate for this subject, as they allow the artist to maintain a certain measure of control over the pictorial process and a high degree of resolution.

The key: resemblance

We are going to draw a female face. First we draw a basic outline of the face, searching out the most pronounced features. A good portrait must bear a certain likeness to the model, and said likeness is determined by the balance of proportions, the exaggeration of the person's characteristic features, the pose, and the rendering of the subject's personality.

Over the foundation of the sketch drawn with violet, the lines are reinforced with a black pencil.

The first modeling with sienna, black, and carmine will distinguish the main areas of light and shadow.

first tonal value. Observing the model all the time, the contrasts are increased by superimposing new shadings over the first ones with warm tones that lend variety to the flesh tones.

Overall tonal value

The secret of a good portrait lies in the nose and the eyes. If we draw these two features correctly, we will have resolved 50 percent of the model's resemblance. Once these basic characteristics have been resolved, the next step, as always, is to create a

Before painting the hair with black, we reduce the contrast of the white paper with some violet shading.

The technique of leaving the clothes only sketched directs the spectator to focus all his attention on the details of the face. Drawing by Miquel Ferrón.

Progression of the modeling

The white color of the paper is used to display the brightest highlights on the face. The shaded areas are insinuated with some faint shading using a sienna pencil. In the flesh colors, there is no need to restrict it to yellow, pink, and earth tones; indeed, drawing with colored pencils allows a wide variety of tones in this respect. Thus, it is possible to superimpose bluish grays in the shaded areas of the face, violet in the cheeks, green in the chin, and tones of orange in the neck and forehead.

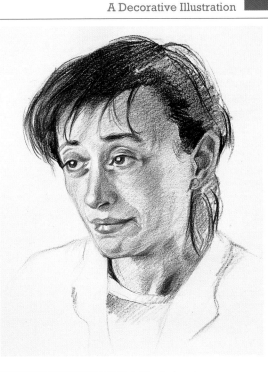

Cleanliness

It is important, especially in portraits or female nudes, to ensure complete cleanliness, especially with everything concerning the skin or flesh colors. A female face should never have stains or dirt. The skin of the female anatomy is characterized more for its smoothness and delicateness than male skin, and the contours of the female body are softer and more rounded. The artist must take the utmost care in this sense. More than ever, the artist must work from less to more, leaving it slightly unfinished if necessary, as there will be plenty of time for accentuating the color later.

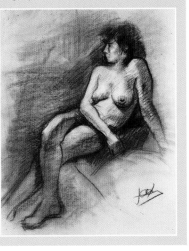

The rounded shapes of the female body call for a delicate and clean finish, without many abrupt tonal transitions. Nude by Miquel Ferrón.

The hair

Before darkening the hair with strokes of black, some shading is carried out with the violet used at the start, which will provide a base for the black. In this way, it is possible to see this color between the shading of darker strokes. This chromatic contrast lends an "air" to the whole, that is, atmosphere, and reduces the harshness of the dark outline of the hair.

The importance of detail

We have already created 50 percent of the resemblance in the sketch. But there is another 50 percent to gain through the modeling. Red gives the cheeks a rosy touch, defines the shape of the nose and the contours of the eyes, and contrasts the lips with respect to the rest of the face. The complete likeness is achieved by adding those tiny details that go unnoticed by the uninitiated.

A DECORATIVE ILLUSTRATION

Colored pencils are one of the cleanest and most convenient artistic media. And, in the field of illustration, their possibilities are far greater than their simple appearance indicates; in large format illustrations, they are irreplaceable for working on details. In the following exercise, we will use colored pencils as the main medium, together with watercolor and an unusual instrument; a stylus.

Watercolor painting, drawing, and etching

First, a large patch of ochre-colored watercolor paint (diluted in abundant water) is spread over the entire surface of the paper to secure the ground. When it has had time to dry, the model, in this case a bird composition, is sketched on top with a sanguine-colored pencil; this tone will later blend naturally with the overall color harmony. With the stylus (you can also do this with the tip of an empty ballpoint pen), the plumage and the texture of the plants are etched, applying enough pressure to leave clearly visible grooves on the surface. This work must be carried out with extreme care so as not to perforate the paper.

Enriching textures

When we begin to apply the first shading, we will see how

A stylus is used to underscore the shapes of the model.

useful the stylus is for enriching color and diversifying the texture. By painting over areas previously etched with the stylus, the grooves stand out in the negative, that is to say, they appear as light lines on a dark ground. The artist must combine within the same drawing different ranges of

pencils, hard ones and soft ones. The hard variety is useful for outlining and drawing details, whereas soft pencils yield more intense and saturated tones.

A grease pencil

Soft colors are created by drawing more or less separated strokes or hatching, but, whatever the case, they should not fill in the entire surface of the paper. A grease compressed pencil is used to bring out certain contours and details of the birds. The pencil must be well sharpened, in order to prevent imprecisions or abrupt changes in the thickness of the line. It is important to go over all those contours that might be

By painting on top, the lines scored with the stylus can be clearly made out.

confused with the color of the background. The rest of the tones should not be overly saturated.

The final applications of gouache

Once the whole scene has been colored in, we will naturally have to adjust certain tones if the drawing is to obtain the desired effect. We persevere, above all, in the contrast of the plumage and the markings on the cat's back. Finally, we add some white gouache to highlight the light tones of the birds' plumage and to obtain a greater effect of volume. This medium improves the contrast between the shapes and the clarity of the whole.

Having colored the coats of all the animals, it is useful to outline certain forms with black.

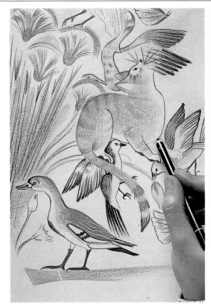

The advertising drawing

Even though the use of colored pencils is not very frequent in the advertising world, there are graphic designers that know how to exploit them to their maximum potential and render works of outstanding quality. The most widespread use of colored pencils in this field is for drawings that, executed with airbrush techniques, would otherwise appear mechanical, flat, and artificial. With colored pencils, they appear more pleasant and delicate.

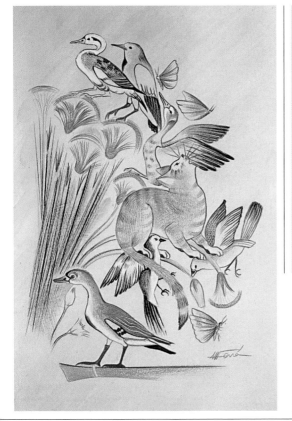

The final result is a highly decorative composition. Drawing by Myriam Ferrón.

TECHNIQUE AND PRACTICE

FEATHERING

The feathering technique consists of drawing a succession of short and soft strokes over an area covered with another color. In order to achieve a more atmospheric and rhythmic effect and a harmonic feel, the strokes are superimposed over one another. This is an ideal technique for softening the most pronounced margins and for executing subtle transitions of light and shadow.

The subject is a person asleep in bed, a scene that displays interesting contrasts of light.

Expressing unity

This is an excellent technique for use on top of a monochromatic drawing with colored pencils, when the most pronounced margins must be softened or subtle transitions between light and shadow must be achieved all over the drawing. It is an important and apt procedure for expressing unity. It consists, in essence, of forming an ordered succession of series of more or less similar strokes.

The first short strokes

We will draw a sleeping female figure. After drawing

The preliminary drawing is created with charcoal. The lines are then partially erased and the painting begins.

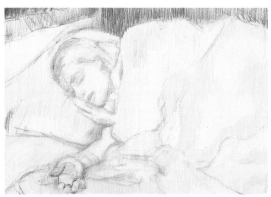

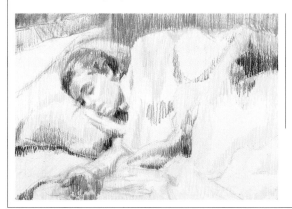

the preliminary drawing with charcoal, we erase the black charcoal lines so they do not appear too intense; we only need a faint outline. We begin by drawing the areas of light with an area of short strokes of delicately shaded yellow. Next the same must be done for the areas in shadow, combining a

The aim of the first applications is to resolve the areas of greatest contrast.

The succession of strokes produces and optical mixture of colors that recall pointilism.

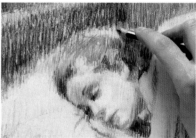

The contours must not be drawn. They are differentiated by the contrast between different areas.

violet tone with a magenta. The intermediate tones can be resolved with sienna and cyan blue. Instead of pressing down too much, soft strokes are drawn that always follow the same vertical orientation.

Superimposing and juxtaposing

More colors are added in an attempt to cover all the white areas of the drawing except the brightest highlights, such as the pillow.

Gradually, the lines will be made more intense by increasing the pressure over the paper. The enlarged details show how the accumulation of strokes modifies the basic colors, producing a clearly divided color effect.

Characteristic lines

With this technique, the surface of the drawing acquires an appearance akin to the barbs of a feather. The accumulation of vertical strokes modify the basic colors, giving rise to subtle optical mixtures that recall, in certain cases, Impressionist painters like Degas, who regularly utilized this method in his pastel paintings.

Opening up whites

Since it is very difficult to erase colored pencil with an eraser, dense applications of colored pencils, those saturated with color, can be scraped away. Using a knife and taking the utmost care not to perforate the paper, the artist scrapes away the color. Thanks to its wax component, colored pencils allow white areas to be opened up with a knife.

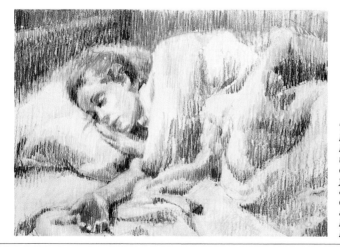

The drawing is based on the balance between the highlights, drawn with tones of yellow and orange, and the shadows, drawn with blues and violets. Drawing by Mercedes Gaspar.

THE ATMOSPHERIC DRAWING

The simulation of the intervening atmosphere is one of the effects that is most often used by the artist to lend the work a sense of space and depth. The effect of distance is created through the discoloration of the grounds as they recede. For the following drawing, we will work with only the three primary colors. The use of only three colors provides an added challenge to the work.

Working with tenuous colors

The atmospheric effect in a landscape is an optical illusion produced by the water vapor and particles of dust present in the air, which reduce in part colors and shapes in the distance. This implies that the artist must work very softly, without applying undue pressure on the pencil, in order to achieve a sfumato effect so characteristic of a landscape atmosphere. First, we sketch the subject, that is, the most important lines that delimit the space of the paper. We can do this with a neutral color, but always, remember, in a soft manner.

The color of shadows

It is easiest to start with blue, a color that is always

First the landscape must be studied and then the way in which the colors are achieved must be analyzed.

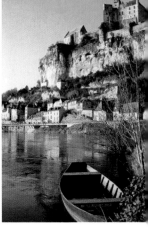

present in any shadow. This provides us with a better overview of both the volumes and the illumination. Remember that it is essential to respect the lines of the sketch, as they are the artist's guidelines that must be taken into account until the work has been completed. The sky must be drawn with a tonal gradation devoid of lines. The blue is applied most intensely in the shadows and the darkest areas. Because we are working without almost any lines, the atmospheric shadings help harmonize the work thanks to the subtle transitions in color.

A layer of yellow

When applying yellow, it must be intensified in the areas of ochre, of the earth and

We sketch with blue and situate the shadows in the manner of a monochrome drawing.

Yellow is superimposed over the blue in the most illuminated areas and in the vegetation.

We contrast the shadows with magenta.

precise and always in the foreground, so as to avoid ruining the sfumato effect of the drawing. In the finished work, we can see that the atmospheric effect enhances the sensation of perspective, giving the impression of a three-dimensional space in the drawing.

A contrasting foreground

In addition to the re-creation of the intervening atmosphere, there are other methods for suggesting the effect of distance in a drawing. For instance, the inclusion of a contrasted foreground, such as a fence or a group of trees, allows the viewer to relate the size of the objects in the foreground with those situated on more distant planes.

vegetation, to obtain yellow-green; somewhat less in the green areas and, even lesser still, in the blue-greens. For the buildings and the reflections on water, we use a medium tone. In the golden and reddish ochres, the color must be applied intensely. It is important to note that, in an atmospheric drawing, the grounds fade in color as they recede; the result of which is less intense tones and fuzzier outlines.

Final deliberation

Finally, we paint with magenta. The objects whose coloring requires only two primary colors are easy to do. But, those in which neutral colors are present are significantly more complicated. The contrasted shadows must be

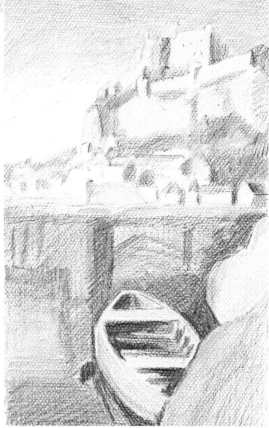

Once again combining the three colors, here much more saturated, we define and contrast the drawing.

TECHNIQUE AND PRACTICE

THE WHITENING TECHNIQUE

Colored pencils have one particularly unique characteristic that is due to their physical composition. It is the possibility of blending or toning down certain lines by painting with light gray or white over other colors, lending the drawing a more harmonious appearance, with a softer and lesser contrasted chromatic result.

Polishing

The technique of whitening consists of polishing, equalizing, and mixing the color over a surface covered with shadings and running a blending stump, a white pencil, or an eraser over the top. In addition to blending the colors, this procedure grinds down the pigment particles and lends a glossy appearance to the finish.

When a layer of white pencil is superimposed over another color, the two colors blend together.

Tonal technique

If we wish to whiten an area, we must first do the drawing by using the tonal technique. As always, working from less to more, the value is obtained by combining the shadings and the visible line, and bringing out the texture of the paper, with a soft and harmonious result. Next, when the drawing phase is complete, we apply an intense layer of white.

The model is a narrow street bathed in intense sunlight.

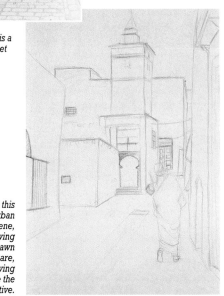

Because this is an urban scene, the drawing must be drawn with care, without leaving aside the perspective.

Whitening tones

The effect of applying an intense layer of white over shadings makes the initial color appear duller, more pastel-like in appearance, that is, with softer and less saturated tones. With white pencil, the strokes blend and cancel out the characteristic effects of the texture of the paper. It is not necessary to cover the entire surface of the paper with white tones; it is also possible to obtain gradations that range from bright and intense colors to a general whitish light tone. Care must be taken when working with this technique, as the paper can tear very easily when applying the necessary pressure over the surface.

The final result

Drawings developed with this technique have the appearance of a pastel painting. If we apply successive layers of color and polish each one of them, we are able to achieve a very smooth surface, similar to marble. The blending gives

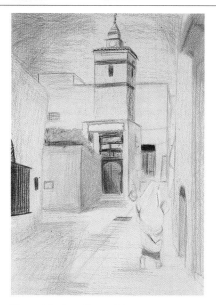

The work begins with a traditional shading. We must take into account that the colors will be mitigated by the application of white.

The first applications of white are applied when the tonal value of the whole is at an advanced stage.

way to a homogeneous application of color; in this way, we obtain creamy and toned-down colors, whose texture is unlike that of direct color applications. The tone is lightened, once it has acquired another quality.

Lightening and darkening

The slightly waxy quality of the lead can be seen under the white and gray layers, with little coloring capacity. The colors blend, barely affected by the gray or the white. Certain tones, having been covered by gray, not only blend but darken as well.

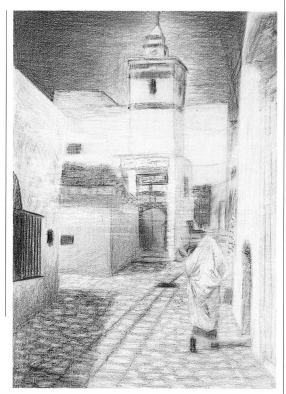

The technique of whitening sometimes recalls the range of colors obtained with pastels. Drawing by Esther Rodriguez.

TECHNIQUE AND PRACTICE

DRAWING A STILL LIFE

The still life is a composition normally comprising everyday objects. Such objects are convenient for composing and give artists the freedom to work at their own pace and practice drawing with colored pencils. With the question of synthesis, the illumination and textures are the main attractions of this genre. Given that the still life is almost always static, it is worth finding things that have enough vitality to arouse the interest of the spectator.

Preliminary drawing

The sketch is drawn with a gray pencil, taking care to include all the necessary details. Shading drawn with a yellow colored pencil fills in the chair; lightly, the briefcase is shaded with brown and carmine, leaving the highlight on it untouched. Over the soft tones of the first shading, we increase the dark tones in order to define the shaded sides of the objects. The highlights on the umbrellas are obtained by leaving areas reserved; the white will be represented by the white of the paper.

Handling the highlights and shadows

The subtle shades gradually add different tones to the colors of the objects. Luminous ones in the areas of light, and dark ones in the shade. Being white, the shirt is defined by the areas of soft and bluish shadow. A useful technique for drawing the creases and folds of the

material consists of running the razor blade flat over the paper to open up white areas or color gradations.

Tonal progression

The shading can be carried out very softly, without entirely filling in the pores of the paper, or even with great pressure, thereby filling in the pores completely. In this way, the artist can carry out superimpos-

ing and transparent effects, always from less to more; that is, the blendings between colors always appear better with soft shadings, always bearing in mind the direction of the light. Sharp contrasts can be extended so as to allow parts of the underlying colors to show through. By intensifying the contrasts, we recommend the use of black for the metal structure of the chair, the cap, and the shaded leaves of the plant in the background.

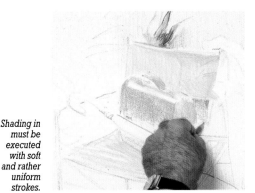

Shading in must be executed with soft and rather uniform strokes.

Blending color

If we try to blend some color with a conventional pencil, we obtain no visible result. The way to apply the color in a stumped layer consists of reducing the lead to powder and then spreading this powder (you can obtain colored powder from the lead by using scraping it with a knife or blade). This technique is useful for obtaining concrete effects, such as, for instance, a background to represent a sky.

The blending is obtained by rubbing the powder obtained from the lead.

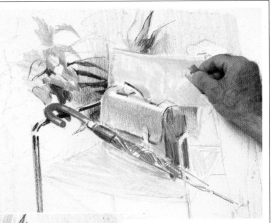

Density of color in certain areas can be removed with the flat knife.

Final corrections

The colors added in the last moment seal the pores of the paper in the areas of greatest contrast, whereas in the most luminous areas the background color is still visible. The next step involves resolving the details of the objects' tex-

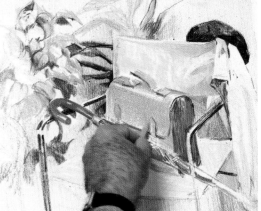

tures. The leather briefcase, the most velvety part of the chair, and its smooth and shiny frame are given an appropriately smooth and satiny treatment. The background appears unfinished, executed with a light tonal gradation that ranges from the earth color at the top to the violet colors at the bottom.

The last applications of color contrast and define each one of the objects. Drawing by Vicenc Ballestar.

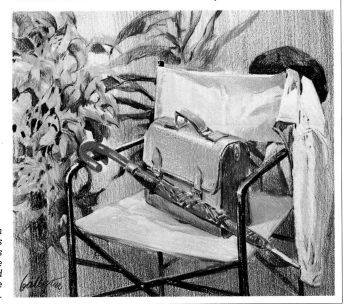

A progression in the values of the tones will make the highlights stand out from those that are not.

TECHNIQUE AND PRACTICE

SGRAFFITO

Painting with colored pencils over a previously etched paper is an ancient technique of illustration, which many professionals have come to use once again. By adding some light shading in pencil, the lead does not penetrate the incisions of the etching, and they appear as white lines that lend graphic variety to the drawing.

The metal stylus

A stylus is used in the sgraffito technique to score or scratch lines into the paper. When scratching or etching the surface of the paper, extreme care must be taken not to scrape it, which means that if you do not have a stylus, you should not use instruments that are too sharp. If you plan to use this technique frequently, you can make styluses of various thicknesses so as to maintain a greater control of the effects. A metal ruler is required for scratching straight lines, since the stylus would destroy the side of a conventional plastic ruler.

The outline of the model is drawn with the stylus, which leaves grooves in its wake that will act as reserves of the white paper.

Practicing sgraffito

We look at the model. On a sheet of fine tracing paper, we draw the outline of the bird with a graphite pencil. Next, we place the sheet of tracing paper over a sheet of white drawing paper (which should be at least 90 lb.). The sheet of tracing paper must be placed on a soft surface, such as a rubber mat or a small particle board. Using a stylus with a rounded point or the tip of an empty ballpoint pen, we go over the pencil lines (over the tracing paper), pressing down hard enough to create grooves in the drawing paper below.

The use of the stylus to attain graphic richness is widespread among illustrators. Drawing by M. Angels Comella.

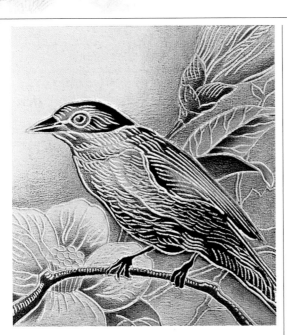

If we paint with colored pencils applying the tonal technique, the previous etching will remain visible by highlighting the contours in low relief.

After removing the tracing paper, we will have obtained a type of drawn etching created with the furrows and grooves.

grooves enrich the texture and the end result. The details and finer strokes of a drawing are sometimes very difficult to obtain by employing only colored pencils; it is for this reason that the sgraffito technique is so frequently used, as the effect of the stylus increases the sensation of detail in all textures.

Texture and variety

It is important not to repeat the same type of sgraffito in all parts of the model. The intensity of the furrow must be varied and its width broadened, according to the demands of the subject, searching out graphic variety in contrast with the areas of color where the pencil line is visible. The texture of the etching must be combined with color alternations and mixtures. The sgraffito technique with colored pencils is almost a traditional technique among illustrators, which can then be enhanced with touches of gouache or pastel.

Shading the drawing

The grooves in the paper remain perfectly visible after shading over them with colors, and the lines formed by these

The scratching technique

Thanks to their waxy composition, colored pencils allow the use of the sgraffito or scratching technique. A drawing executed with intense colors and blendings contains a certain thickness of color. This layer of pigment color is easily removed by scratching the area with a round-pointed object. With each stroke we remove the wax from the second color, which comes away with ease, leaving the color of the first layer visible.

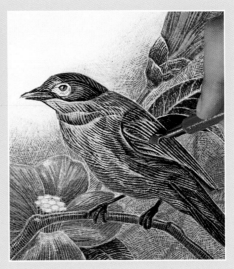

A round tip is used to scratch the drawing, removing the color with ease. Drawing by Miquel Ferrón.

FROTTAGE

This is one of the most widely used techniques for obtaining textures in the drawing. A textural base is created by rubbing the pencil lead flat over the surface of the paper, which has been placed on a rough surface. The grain and texture of this surface establish the background of the paper. Depending on the material chosen, it is possible to achieve all manner of effects: lines (corrugated cardboard), undulations (on relatively dry wood), and so on.

The texture and materials

Frottage is an automatic technique developed primarily by the Surrealist artists. It allows textural effects to be transferred to the paper, such as the tactile feel of the material's surface. This is achieved by laying a thin sheet of drawing paper on top of any rigid surface that has a pattern or pronounced texture: boards, textured metal, a wicker basket, knitted materials, reliefs, tiles, and so on.

It is worth taking the time to explore all kinds of surfaces in order to find interesting textures. The technique consists of rubbing the colored pencil on its side to transfer the texture to the paper.

Any rough surface can be used to obtain interesting textures by rubbing with a pencil.

Give free reign to your imagination

Frottage is not a technique to be practiced at random. The artist must know how to choose material surfaces properly, be it for the interest in the texture or for the forms its contains. You must give free reign to your imagination and try to recognize surface textures that could be used for faces, heads, animals, trees, and other

Max Ernst

The origins of the frottage technique is usually attributed to the Surrealist painter Max Ernst, when the surface texture of the paneled floor of a small hotel room on the French coast inspired him to

invent the technique. Indeed, in his series of drawings entitled *Histoire Naturelle*, he developed the idea of finding his components of a work of art in the surface texture of objects. Max Ernst held that the technique of frottage was the precise equivalent of automatic writing; however, at least in the choice of materials traced, there is always some conscious artistic intervention.

Max Ernst. The Only One and Its Property, Frottage technique, pencil on paper (Jan and Marie-Anne Krugier-Poniatowski collection).

A collage can be composed by using different sheets of fine paper with different well-defined textures. Drawing by Esther Rodriguez.

with another color, a model similar to the first color is produced, although the lines and shapes are offset. This can be carried out with two or three colors, but no more, otherwise the vibrancy of the effect could be lost. It is worth experimenting with different media and colors, in order to achieve different effects and chromatic variations.

Rub, cut, and paste

It is not necessary to carry out the frottage directly over the paper of the definitive drawing. We can trace a number of interesting textures beforehand on various sheets of fine paper. Then we can cut

familiar shapes, in the same way you would contemplate cloud formations.

Offset frottage

If after having practiced the frottage, we move the paper slightly to one side and begin rubbing over the same surface

It is important to know how to choose the right texture for each area of the work. Drawing by Esther Rodriguez.

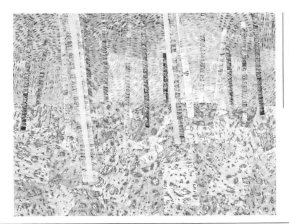

them out and paste them on to the paper with any shape, in the manner of a collage. For this, patience and perseverance are necessary, as well as the capacity to know how to choose the right texture for each area of the work.

The technique of frottage lends the work immense expressiveness and a more painterly quality. Composition by Esther Rodriguez.

EXPRESSION

An expressive interpretation of the model emphasizes the formal aspects, the consistency of the volumes, and the pure harmony of the chromatic and linear composition. In this type of drawing, the artist neither strives to express the character of the scene nor the moment in which it is captured, but rather creates an architecture of forms and colors through a highly personal vision of the model.

Expressiveness

This is a difficult concept to define clearly and without ambiguities. Applied to the colored pencil drawing, we can say a work is expressive when it has life—an inner vitality—and when the model appears to be animate as opposed to a pure and distant representation. If the artist is able to inject life into the work we can say he or she has achieved expressiveness. This expressiveness can be attained with the use of saturated colors, with an intense and energetic stroke, or by starting from a formal deformation.

The role of color

The interpretation and expressiveness of the model in a work depends on the artist's capacity of combining the real image of the model with the artist's memory. The artist's personality is what creates a memorable image, and often it is better to let instinct dictate

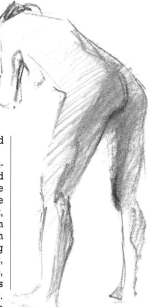

The aim of the stroke and the effect of the color are fundamental for lending expressiveness to the model. Drawing by Miquel Ferrón.

when to follow the rules and when to deviate from them.

In moments of true inspiration, it is essential to disregard theories and color rules, advice and prior intentions, and give free reign to your pure instinct, to a personal interpretation of the color. Working with contrasting colors, combining warm tones and cool tones, light colors and dark colors, is one of the possibilities available to current-day artists. In such circumstances, realism is relegated to a secondary position, although this does not imply that you should pay no attention to the aspects of composition and questions concerning the proportioned form of the subject.

Expressive strokes

In order to achieve an interesting line in our drawings, we have to work fast, without lifting the pencil off the surface of the paper, with barely any shading, only following the shape of the subject with a continuous and tranquil line, or by nervous and discontinued strokes. The weight and thickness of the line, its flow and experimental character, the way in

When coloring, it is best to give free reign to inspiration to achieve works like this. Drawing by Oscar Sanchis.

*Berthe Morisot.
Eugene and Julie
Manet, 1886
(private collection)*

which it can be continuous or discontinuous are just a few of the techniques that can be exploited by the artist in order to create effects of great expressiveness. In skillful hands, the line can be used to describe almost all the visual effects that the drawing can produce.

Landscape sketches and notes need not be conventional, but rather they must be based on a vigorous stroke than tends to suggest the shapes.

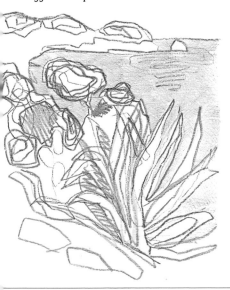

Expressionist inheritance

In contemporary drawing techniques, the influence of expressionist techniques and the influences of abstract art can be observed. In contemporary drawing, it is unnecessary to explain forms in detail, but they must be clearly understandable. The traditional concepts of balance and composition in this type of work may be altered.

Colored pencils continue to be used nowadays, combined with other media, in compositions of a more abstract nature. Drawing by Gabriel Martin.

TECHNIQUE AND PRACTICE

NIGHTTIME SCENE ON COLORED PAPER

A nocturnal urban landscape provides the artist with interesting chromatic effects, thanks to the presence of a fading glow from the twilight whose shadows lend the scene an air of mystery. These drawings are converted into unconscious fantasies, yielding to a representation that is often more symbolic than natural in its interpretation. In this exercise with colored paper, we will learn about the luminous effects achieved by drawing a night scene.

● ●

Nighttime

The night can also provide the artist with infinite possibilities of capturing scenes that deserve to be rendered. The nocturne, while widely used in the field of music, is overlooked in the field of painting, and not for lack of inspiration; bustling city life, the variety of highlights and shadows, illuminated facades, neon lights, advertising, and store windows are more than enough stimulus for drawing urban nighttime scenes.

The nocturnal landscape offers numerous possibilities for the amateur artist.

Line drawing

To carry out this exercise, we will use a medium-tone sheet of ochre-colored paper.

With a well-sharpened pencil, we sketch the buildings, situating each one of the openings in the facades. Care must be taken when drawing the perspective of the street, as its correct representation depends on the depth of the work. The first shadings situate the darkest shadows in the background.

How to paint light

To paint the streetlight, first it is necessary to know that artificial lighting shines both in a straight line and radially. Therefore, the ray or source of light must be painted white at first and then the color must gradually be yellowed, in the

The architecture of the model must be given a linear treatment, without forgetting the perspective.

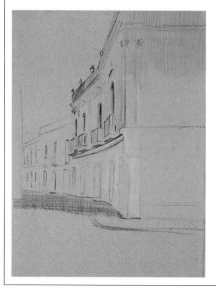

The light from a streetlamp expands in a radial fashion, forming yellow and orange gradations.

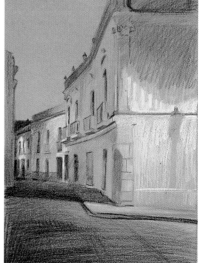

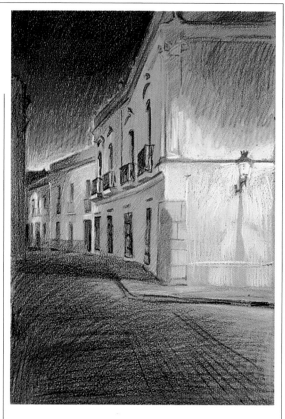

The final use of black is crucial for bringing out the contrasts and the volume of certain objects. Drawing by Oscar Sanchis.

manner of a gradation, as its expands outward. The end result must be a source of lighting with a halo that gradates from a greater to a lesser intensity.

Nocturnal shadows

Shadows cast by objects give way to unusual and wonderful shapes, which can create interesting dynamic effects within the work. These shadows must be sharply defined when they are close to a streetlight and gradually be made more diffuse as they recede.

The use of black

Black is used to begin intensifying the contrasts in the windows, balconies, and curbs of the sidewalk of the lower half of the foreground. The black shadings in varying intensities cover the different areas of the work with a soft patina, with the exception of the illuminated facade. The sky is given a tonal gradation that ranges from dark blue to white.

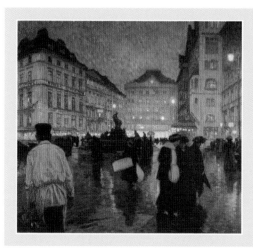

Lovers of the night

Romantic painters, Symbolists, and Divisionists showed great interest in the effects produced by artificial lighting in the city by night. The main interest for these artists was the vibration of the light. The nocturnal landscape was not limited to the city; it could also be developed in a rural environment: a starry night scene, a landscape lit by the light of the moon or its reflections on the shore of a lake were also sources of inspiration for them.

Ferdinand Kruis. Night in the Neuer Markt, 191, Historisches Museum der Stadt (Vienna, Austria).

CREATIVE TECHNIQUES

Colored pencils can also be combined with other pictorial techniques, in order to complement the drawing with a wide variety of effects. It is essential for the painter to be aware of the possibilities of combining all artistic procedures, in order to use them as a resource whenever necessary.

Combining with watercolor

Colored pencils combine perfectly with watercolor, and from this combination the most delicate and subtle contrasts found in the field of illustration can be achieved. The pencils constitute a useful complement for highlighting, shading, and lending volume to shapes previously painted with flat watercolors.

In the case of watercolor pencils, this combination reaches a point where it becomes difficult to distinguish where one medium ends and the other one begins. Nonetheless, the majority of pictorial media are too energetic for colored pencil to stand out in them, due to their limited covering capacity. Such combinations are very frequent among illustrators, who sometimes complete their works with touches of pastel or gouache.

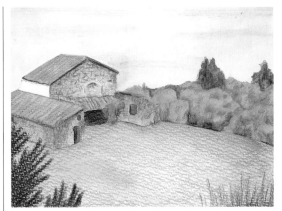

The combination of collage with watercolors allows fusions of washes and strokes. Work by Esther Rodriguez.

Collage

The collage technique consists of sticking pieces of freely structured paper on top of other paper. By combining this technique with colored pencils, you will discover that it is possible to create pleasant and suggestive compositions without having to worry about academic exactness in the forms and volumes of the objects. The collage is a purely experimental and reflective method, which means there are no strict rules, therefore it can be as simple or as complex as you desire:

Colored pencils are an ideal complement for watercolor illustrations like this by J. M. Gabur.

The collage offers interesting creative possibilities if we know how to combine it with colored pencils. Work by Esther Rodriguez.

opaque when dry. This covering and its milky appearance has made it a very useful medium for retouching or for completing drawings begun with colored pencils when working on colored paper. In colored pencils, the white is barely used and normally only for polishing or working on colored paper. This is a highly versatile medium, as the artist can choose either to exploit the opacity or to create soft and subtle effects akin to watercolor.

MORE INFORMATION

• Sgraffito, **p. 86**
• Frottage, **p. 88**
• Expression, **p.90**

abstract or figurative, realist, or purely decorative. The collage technique implies unifying ideas and visual elements that result in a satisfactory composition.

Pencils and gouache

Gouache differs from watercolor in that the colors are less transparent and become

Wax crayons and pencils

Whereas colored pencils are known for their velvety texture, waxy pastels produce intense covering treatments. This fact indicates that it is possible to draw strokes over shading done in pencil, but never the other way around. The waxy and malleable consistency of layers of pastel prevents the pencil stroke from adhering and, instead of painting, the tip of the pencil will open up whites over the paper as with the sgraffito technique. Therefore, the order of the application must always be inverse.

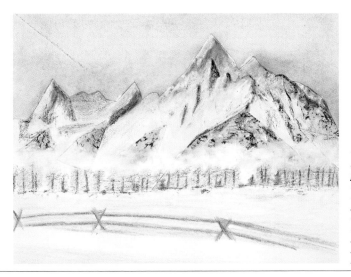

The collage and gouache provide a textured surface that can be highlighted by drawing over the top in pencil. Drawing by Esther Rodriguez.

English-language edition for the United States.
its territories and dependencies, and Canada
published 2003 by Barron's Educational Series, Inc.
© Copyright of English-language edition 2003
by Barron's Educational Series, Inc.
Original title of this book in Spanish: *Lápices de Colores.*
Copyright 2002 by Parramón Ediciones, S.A.—
World Rights
Published by Parramón Ediciones, S.A. Barcelona, Spain

Author: Parramón's Editorial Team
Illustrator: Parramón's Editorial Team

All inquiries should be addressed to:
Barron's Educational Series, Inc.
250 Wireless Boulevard
Hauppauge, NY 11788
http://www.barronseduc.com

International Standard Book Number 0-7641-5547-4

Library of Congress Cataloging Card No.: 2001098714

Printed in Spain

9 8 7 6 5 4 3 2 1

Acknowledgments
We wish to thank Pilar Amaya, M. Angels Comella, Oscar
Sanchis and Esther Rodriguez for the drawings provided
for this publication, and to Ani Amor for her collabora-
tion as a model.

Note: The titles that appear at the top of the
odd-numbered pages correspond to:

The previous chapter
The current chapter
The following chapter